ART OF

Modern India

ART OF
Modern India

Balraj Khanna and Aziz Kurtha

with 133 illustrations in colour

THAMES AND HUDSON

For Francine and Nadira

© 1998 Thames and Hudson Ltd, London
First paperback edition

British Library Cataloguing-in-Publication Data

A catalogue record for this book is available from the British Library

ISBN 0-500-28046-0

Printed and bound in Singapore by C.S. Graphics

Contents

Introduction 6

The Bengali Cultural Renaissance 8

The Emergence of Modern Art in India 12

Tagore and Sher-Gil 15

1947, A Turning Point 20

Shifts of Emphasis 24

Individualism 27

New Horizons 35

Magic in Realism 38

A New Phenomenon and Young India 43

The Future of Contemporary Indian Art 46

The Plates 49

Biographies 130

Bibliography 141

Acknowledgments 143

Index 144

Introduction

The current art scene in India is one of the most vibrant in the world. During the past few decades in particular, the country has experienced a blossoming of the arts on a scale not seen since the time of the great Mughals in the sixteenth and seventeenth centuries. There is a luxuriant upsurge of new talent alongside which galleries in the various big cities are mushrooming. More interesting still is the fact that Indians themselves are buying their 'modern art' seriously for the first time. Furthermore, even though contemporary Indian art shares many characteristics with the art scene in the West, it remains free from the anxieties Western art faces as it strives for originality in this age of post-modernity. Indian art today is refreshingly unselfconscious and, being essentially indigenous of spirit, it is firmly rooted in the Indian psyche.

Quietly, unaccompanied by the fanfares of publicity which developments in Western art attract, an artistic revolution of a sort is in the process of unfolding in India. There have been no heraldic movements, nor emergence of any new 'isms' and schools. This should not come as a surprise to anyone, for India has produced great art since the Indus Valley Civilization in the second millennium BC, though the names of the great artists of the past remain unknown to us because Indian society has always considered the authorship of a work of art less important than its actual creation. Traditionally, art was made for a purpose – for ritual, contemplation or delectation – and it was made by the people for the people in a fluid social context, in which the egos of its makers merged with the expectations of its beholders. Irrespective of frequent invasions, unrest and turmoil, art flourished in India on so many different levels – from the holy temples and the courts of the maharajahs and the nawabs, down to village, tribal and occult circles. Century after century, the endless search for expression and the ceaseless artistic outpouring of a prolific people continued like a mighty river sluggishly surging on.

The greatness of ancient Indian art is permanently enshrined in the stone sculpture of early eras, such as those of the Mauryas (323–185 BC), the Kushans (late 1st–3rd century AD) and the Guptas (320–550 AD), among the most dynamic and magnificent created by any civilization. That such achievements were concomitant with developments in other cultural spheres is amply demonstrated by the literary heights

attained by the great fourth-century poet and dramatist, Kalidasa. Painting, by its very nature, did not survive the onslaught of time except in the fabulous frescoes of the Ajanta caves, painted by Buddhist monks between the 1st century BC and the 5th century AD.

Indian painting, however, evolved into a breathtaking genre with the arrival in India of the Mughals in the sixteenth century. Sweeping down from Central Asia, these descendants of Tamerlane and Genghis Khan brought with them Persian court artists and sophisticated refinement considered the finest of the times. Under the broad-minded patronage of the early Mughal emperors, a remarkable synthesis took place between their imported tastes and the indigenous Indian sensibility. This spread to other princely courts and resulted in what are known today as Mughal-Rajput miniature paintings, which are generally regarded as being among the most beautiful images ever created. Their makers kept alive the flame of creativity in India for as long as they had patronage.

But then, alas, came a long and a crippling hiatus which began when the British assumed control of India in the eighteenth century and lasted for two hundred years. Like the Mughals before them, the British brought their own tastes, but the new rulers had no interest in any form of cultural synthesis, nor could they perceive the genius of the Indian people. Declaring their art to be 'bad' or 'offensive', they failed to channel the native talent into any significantly new direction or give it the patronage it had traditionally needed to survive.

The conquest of India by the British had been a protracted and a bloody affair requiring great political skill. Their spectacularly successful divide and rule tactics had caused not only constant internecine warfare among Indian rulers, but also with the British themselves which resulted in political and social upheavals with calamitous repercussions on the arts of the country. Yet, curiously, for three very good reasons, modern Indian art owes much to the British colonial period, however ironic this might sound.

Firstly, because the key to its origins lies in the great cultural ferment in Bengal in the second half of the nineteenth century, itself a paradoxical consequence of the stability provided by British rule. Secondly, this period witnessed certain changes which, though quiet, were to have far-reaching and long-lasting effects felt in India even today. Foremost of these was India's decisive contact with the West, a direct result of the introduction of the British system of education. The British reasons for this were entirely pragmatic – they needed a class of middlemen educated along English lines with whom they could communicate easily and who would run the bureaucratic machinery of their vast empire. The British did not anticipate

either how enthusiastically the middlemen would perform or how the English education system would affect the rest of India. It opened doors to new ideas – scientific, technical, democratic – that were shaping Europe, preparing Indians to seek an independent destiny.

Lastly, but equally importantly, India recovered its long-lost pride, confidence and self-esteem, and again, this was made possible entirely, though inadvertently, by the British. For decades, British scholars had been busy unearthing India's past through a systematic and scientific study of ancient Sanskrit texts, its extinct languages, neglected monuments and archaeological sites. The result had been staggering discoveries, revealing the bewildering riches of India's ancient architectural, literary and artistic heritage. Once more, the motives behind the painstaking efforts of these worthy scholars were largely self-serving – besides the explorers' delight at having made a rare find, their discoveries brought them laurels in the academic world, enhancing their reputations and furthering their careers. But for the Indians, their heroic achievements had consequences the scholars had neither expected nor sought – the great cultural renaissance in Bengal, which was to be the first step in India's long march to freedom.

The Bengali Cultural Renaissance

Calcutta, the principal city of Bengal and the capital of British India, became the epicentre of this cultural flowering. The harbour city, through which passed the bulk of India's trade with the rest of the world, was in the last quarter of the nineteenth century enjoying a commercial boom India had not known in recent times. Dotted with an increasing number of factories and mansions of the *nouveaux riches*, it came alive with song, dance and street theatre, creating an almost palpable mood of excitement. For the first time, perhaps, Indians, and Bengalis in particular, began to take a missionary-like look at India in order to reform it, make it progressive and take it forward.

Western-style education brought Western-style reasoning, cutting through superstition and dogma. Numerous new institutions of social reform, such as Brahmo Samaj, founded by Raja Ram Mohan Roy as early as 1829, began to 'modernize' Hindu society. Schools and colleges grew in numbers, making the

Bengalis discover the riches of their language; printing presses mushroomed, bringing a constant flow of new literature. Alongside these innovations, there appeared on the scene a new professional middle-class which was conscious of its destiny. On an all-India scale, the quick expansion of the railway (intended essentially for rapid troop movement after the so-called Mutiny of 1857, which nearly cost Britain its Empire) made communications swifter, enabling the growing Indian intelligentsia to coalesce and become increasingly aware of its 'Indianness' over and above the traditional divides of religion, language and caste. There now emerged a sense of India as one nation which was to grow and grow until, half a century later under Mahatma Gandhi, it became a force too formidable for the British to thwart.

At the fountain-head of this exuberance was a single Bengali family, the aristocratic, multi-talented Tagores. They composed poetry, they wrote and staged plays, they sang, they painted. They even designed their own clothes and furniture when the clamour among Indians for things Indian grew during the Swadeshi movement of 1905. The most celebrated of their number, the poet Rabindranath (1861–1941), went on to become, in 1913, the first Indian and first non-white to win the Nobel Prize for Literature (for which he was knighted by the British in 1915). He founded the great Visva Bharati University at Shantiniketan in 1917. His nephews, the brothers Gaganendranath (1867–1938) and Abanindranath (1871–1951), distinguished themselves as the first 'modern' Indian artists. Although their uncle also took up painting in his later life, aged sixty-nine, it was these two – especially Abanindranath (who later proved to be the most influential Indian artist of the early decades of the twentieth century) – who emerged as the leaders of the so-called Neo-Bengal or Bengal School, also known as the Revivalists.

Aided by the remarkable Englishman, E. B. Havell (principal of the Calcutta School of Art from 1896 to 1908 and the first Briton to condemn English art education as unsuitable for Indians), and also assisted in his efforts by India's greatest art critic, Ananda Coomaraswamy and the gifted painter Nandalal Bose, Abanindranath tried to breathe new life into Indian art from the dawn of the new century. Instead of looking towards the all-powerful West, he and the Revivalists turned to India's own glorious past, to the riches of its great epics and the wisdom of its transcendental philosophy. Inspired by the frescoes of Ajanta and by Mughal-Rajput paintings, they attempted to create a new voice for India's long-dormant artistic psyche.

But what of traditional Indian art itself at this time? At the turn of the century, after nearly one hundred and fifty years of British rule, what little indigenous art there was consisted of paintings made

to order for the British. Called the Company School, after the East India Company, which had been responsible for establishing British hegemony over the sub-continent, this genre of painting began to assume a distinctive form early in the nineteenth century because it catered exclusively for English tastes. The subject matter varied from the exotic Indian flora and fauna for the benefit of natural history institutions in Britain, to local social types and customs to give the public back home a glimpse of the lifestyles of the people Britain ruled. Given their genius, the Indian artists naturally came up with some exquisite works, but the British did not accord these paintings the status of 'art', rather considering them as a straightforward visual record. Although now highly prized, these paintings provided less than inspiring employment for highly gifted artists who were accustomed to depicting what moved them and what was true to their lives – folklore, mythology and court life.

As far as sculpture was concerned, there was hardly any to speak of save wood carving in South India and some marble work in Rajasthan. Rendering of the human form in stone is an anathema so repugnant to Islam that the zealous Muslim conquerors had smashed stone imagery depicting such themes wherever and whenever they could. Starting with the Afghan invader Mahmud of Ghazni in the eleventh century, all Muslim adventurers in India had systematically destroyed Hindu temples and the great works they housed. Thus, the noble Indian sculptural tradition of the Mauryas, Kushans and the Gupta dynasties; of the Chola period (11th–12th centuries), and the temples of Khajuraho and Konarak (10th–14th centuries), died too. While the majestic Mughals had been great builders, their abhorrence of statuary prevailed throughout their long rule – Emperor Aurangzeb in the latter half of the seventeenth century had raised the ancient Hindu temples in the holiest of Hindu cities, Banaras, to the ground. On their remains mosques were erected using the very stones which had once supported those elegant edifices.

When the British exiled the last Mughal potentate (now 'emperor' in name only) to Rangoon in 1858, all that remained of Indian sculpture were mass-produced models churned out for pilgrims or for lesser local temples by artisans at famous centres of worship. Not until the 1930s, at Rabindranath Tagore's university at Shantiniketan, would there be a serious attempt to resuscitate Indian sculpture under the spirited leadership of one of its visionary teachers, Ramkinkar Vaij (1910–80), now hailed as modern India's first and foremost practitioner of sculpture. And while there have been other eminent sculptors since 1947, such as Amarnath Sehgal (b. 1922) – the first Indian artist to be honoured with a one-man exhibition at the Musée d'Art Moderne, Paris, held in 1964 – Somnath Hore (b. 1921) and Sankho

Chaudhry (b. 1916), it would be another half century before India would throw up sculptors of international standing, notably Anish Kapoor (b. 1954) and Dhruva Mistry (b. 1957).

With its old social and cultural institutions dismantled, India was forced to accept the will of its new rulers as well as their ways. Indian culture, once great and vibrant, had by now become moribund in the absence of a driving force, its arts lifeless for lack of patronage traditionally provided by the Indian nobility. In the middle of the nineteenth century, the British introduced art education by opening art schools in India's leading cities – Chennai (formerly Madras), Calcutta and Mumbai (formerly Bombay). Their aim, however, was not to produce creative artists, but to turn out commercial beings who would be useful to the emerging industry. Strong emphasis was laid on a realism strictly on the lines of early nineteenth-century salon Europe. Students were made to draw from plaster casts, or copy. Sometimes, though rarely, they painted 'landscapes' – ruins which exuded an exotic air – or still-lifes. It was too stiff a system, too limited and, quite simply, too foreign for an Indian psyche seeped in idealism, transcendentalism and symbolism.

However sterile British art school realism was, it was still regarded with awe by a philistine new middle-class India and it resulted in at least one memorable success – the career of the South Indian artist, Raja Ravi Varma (1848–1906). A minor princeling of the house of Travancore, Ravi Varma was a painter in oils, the first Indian to master the technique. He had learnt his craft not from an English art school, but from a visiting European artist at the court of the Maharajah of Travancore, his uncle through marriage. Ravi Varma dazzled turn-of-the-century India by recalling in his oil paintings its ancient glory and golden past. He depicted scenes from the great epics and other literature and, although he also painted portraits, usually of Indian nobility, he became renowned for painting famous incidents in Hindu mythology, giving the personages in them a dress and form later to be adopted by the Indian film industry (a trend which continues to the present day on television). Hugely popular as his colour reproductions became with the masses, Ravi Varma has sometimes been seen by artists and critics of the late twentieth century as a sentimentalist whose work lacks any depth.

The Emergence of Modern Art in India

A dynamic art form that had already been flourishing for several decades – the stunning Kalighat paintings – was being practised in Calcutta when the Bengal School under Abanindranath Tagore and Havell was gathering momentum. Created by anonymous artists as souvenirs for pilgrims visiting the famous temple of the great Goddess Kali, these paintings are today regarded as the most authentic and original art form to emerge in nineteenth-century Calcutta. Anticipating, or possibly even inspiring twentieth-century masters of modernism such as Fernand Léger, they were completely ignored at the time by the *bhadra lok*, the new well-to-do, including the discerning Tagores. They met this fate because they were cheap to buy, and were therefore considered inconsequential. Their makers, the *patuas*, had migrated to Calcutta from rural Bengal early in the nineteenth century and they did not enjoy any social standing. Even Havell, the most enlightened art teacher of the time, and Coomaraswamy (who passionately championed art's functional integrity with life, as poignantly demonstrated by these works) do not seem to have noticed them, though they were to be seen everywhere in Calcutta and had influenced another kind of art form, the Calcutta woodcut.

At the expense of relating his work to contemporary life, the aristocratic Abanindranath Tagore stuck romantically to Indian history and mythology as his chosen subject matter, and painted his pictures with techniques learned from foreigners. Though humble and prolific, the *patuas*, too, painted mythological themes and also made bold social statements through endearingly witty satire. They did not do this in the form of caricature (which Abanindranath's brother Gaganendranath would later attempt European-style), but as the spontaneous expression of gifted artists moved by events and the way of life around them. They had evolved a unique and a highly distinctive style, and perfected a technique using cheap watercolours. Alas, their paintings, called *pats*, began to gain recognition only in the late 1920s, when production had all but ceased. By 1930, no Kalighat paintings were to be seen around the Kali temple in Calcutta because now such souvenirs were being printed in their thousands and could be bought for a fraction of

the price of a Kalighat *pat*. The only artist of the Bengal School to take notice of these *pats* and to be inspired by them was Jamini Roy, who, undeterred by difficulties in his early career, became a legend in his own lifetime.

But before we come to him, it would be instructive to examine the career of his tutor, Abanindranath, the first serious Indian artist in the modern sense of the word. Not yet twenty when he set out to become a painter, there was little to inspire him or act as a role model. The contemporary situation offered him either the defunct colonialist's art form (as practised in English art schools) shipped from an alien culture, or his own, which was equally sterile. Aware of the limitations of both, he boldly opted for a synthesis of the two to which he would introduce influences from further afield – Japan. His early training, in 1890, came from two expatriate artists living in Calcutta, the Englishman, Charles Palmer, and the Italian, O. Ghilardy. From these Europeans he learnt to draw realistically along art-school lines. Highly gifted, he quickly mastered the fundamental techniques and adapted them in watercolours to create a fusion of English academic realism with Mughal refinement and Japanese wash technique. The ever-perceptive Havell singled him out from all the artists in Calcutta, and invited him to teach at his school as his deputy. From there sprang a friendship and partnership that proved highly influential in giving the art of the Bengal School and art education a new direction.

Insisting on 'art's functional integrity with life', as voiced by Coomaraswamy, and its freedom from the stifling rigours of English art schools' narrow approach, they brought ground-breaking changes into their school. For the first time in its 50-year history, they introduced works of Indian art – paintings, sculptures and other artefacts – to the school's gallery. Hereditary master craftsmen came from various parts of the country to teach traditional skills, making it possible for their students to get closer to their own cultural mainsprings in a natural and wholesome manner.

In his own work, Abanindranath continued to paint romantic visions, such as Shah Jahan dreaming of the Taj Mahal or pictures that could well illustrate the *Rubayat of Omar Khayyam* – shrouded in the mists of Japanese washes he had learnt from visiting Japanese artists. Not as highly thought of by the post-independence Indian artists and critics as he had been in the early decades of this century, Abanindranath was, nonetheless, individualistic as exemplified by his *Arabian Nights* series of about forty paintings. But he was so in a wistful way – always looking back nostalgically at an idealized Indian past. He was also original, albeit in a manner which from the distance of eight decades could now appear mannered, sentimental,

even cliché-ridden. Whatever his stature as an artist, his contribution to the emergence of modern art in India remains unquestionable.

Abanindranath and Havell's teaching methods were emulated by future art schools in India, starting with Rabindranath's university, which the poet inaugurated in 1917. His most famous pupil was Jamini Roy (1887–1972). Coming from a typical rural family in an obscure Bengali village, Roy's early career was disastrous. He lived in a state of permanent penury and his work was lacklustre, banal – his pictures were painted in the fashionable 'modern' idiom. His portraits and Fauvist-style landscapes in oils, though competently painted, were typical 'art society' pictures which could not satisfy Roy's restless spirit. Troubled by the inner knowledge that there was more to him than he could express through such works, he began a tortuous journey to discover his own true self, undertaking odd jobs to survive. It was a period of endless frustration with no ray of hope to light his way. Then suddenly, in 1922, when he was in his mid-thirties, he abandoned his tame and unremarkable art practice. Perhaps he had seen the eye-opening exhibition of Bauhaus artists arranged by Rabindranath in Calcutta that winter and it had opened up new vistas to him, revealing how artists in Europe had found solutions to problems that tormented him.

Unlike his former mentor, Abanindranath, and his brother Gaganendranath, whose muses travelled respectively to the Far East and to the West, Roy realized that the answer to his predicament lay closer to home – in his village, in rural Bengal and in Kalighat paintings. Nonchalantly, he incorporated their bold simplicity, linear rhythm and lyricism in his work. He gave up the ready-made canvas and made his own painting surfaces out of cloth, wood, and even mats coated with lime. Using earth and vegetable colours, he evolved his own unique style, though never forgetting his debt to the Bengali village and especially to Kalighat paintings.

In decades to come, following the footsteps of Roy, artists in an independent India, notably K. G. Subramanyan (b. 1924), would be inspired by these remarkable paintings. Their magic would astound visitors to the largest exhibition ever assembled, which toured various museums in Britain in the 1990s, including the Victoria and Albert Museum in London.

Tagore and Sher-Gil

In 1917, Sir Rabindranath realized a life-long ambition and established his innovative university. It had a novel agenda and vision – to create a context for a genuinely all-round development of human faculties and, in his own words, 'to study the mind of Man in its realisation of different aspects of truth from diverse points of view'. This was not to be a degree-orientated establishment, but rather one where East and West met in mutual respect and where education would be central to the growth of the inner self. Far removed from the neurosis of a metropolis, this experiment would be conducted in the serene rural setting of Shantiniketan, where the community of teachers and students would coexist, not in the rigid and formal way of the English education system, but in one of complete freedom, interdependence and self-reliance.

Two years later, in 1919, as the leaders of the world assembled at Versailles in France to reconstruct a world destroyed by the worst war in history, Sir Rabindranath returned his knighthood in protest against the ghastly massacre of hundreds of innocent Indians at Jallianwala Bagh in Amritsar by the Englishman, General Dyer, and quietly opened the Kala Bhavan, the new art wing at his university. He invited the painter Nandalal Bose (1882–1966) to run it, giving him a free hand and a brief which was much after Bose's own heart – that education be broad-based; that tradition, though of immense importance, must not be permitted to hamper the artists' personal development, that they be encouraged to acquire from the West and any other source whatever knowledge and skills they considered enriching. This would evolve into an original vision reflecting their intuition and expression. The whole scheme of education was to be integrated and conducted in an atmosphere of artistic freedom and self-discovery. This was the sort of approach the Bauhaus (which Rabindranath was to visit a couple of years later) had adopted at its inception in Weimar a year earlier.

A product of the Calcutta School of Art and taught by Havell and Abanindranath, Bose took up the challenge with aplomb and the opening of Kala Bhavan in Shantiniketan proved to be a decisive landmark in Indian art. It attracted not only the country's most talented pupils, but also its most gifted and dedicated teachers, such as former students Ramkinkar Vaij and Benode Behari Mukherjee (1904–72), both of whom

were lecturing there by 1930. The former rose to become a leading sculptor of modern India, while the latter emerged as a major painter in his own right (immortalized by his 100-foot mural in Shantiniketan). Formidable men in their own ways, they became highly effective, teaching by example rather than by expounding theories. Both continued to dominate Indian art for the next three decades. And artists trained by them, such as Subramanyan and Chaudhry, would, in turn, become eminent artists and go on to teach at Baroda, the next most important art school to emerge in post-independence India.

Rabindranath Tagore had been a world figure since winning the Nobel Prize for Literature in 1913. But although Britain had honoured him with a knighthood in recognition of the award, he attracted a considerable amount of hostility there – not only for the obvious reason that he, a citizen of a country it ruled, had won the prestigious prize and was in the world's limelight, but also because in 1913 Thomas Hardy, too, had been nominated for the award. This negative attitude was to persist for a long time to come. Britain apart, Tagore attracted huge crowds on his tours in Europe. He packed halls and university campuses where people thronged to listen to the 'wisdom of the East' as enunciated by this patriarch with a piercing gaze and the striking looks of a biblical prophet. He was fêted in post-revolution Russia and was lionized by the French, but he was most popular of all in Germany, where young hysterical students flocked to see him as young people nowadays turn out to see rock stars. The Nobel Laureate was warmly received at the Bauhaus in Weimar and its friendly and dynamic management readily agreed to his request to send an exhibition of Bauhaus artists to India.

This exhibition, the first of contemporary European art in India, was held in Calcutta in December 1922: it opened eyes. The audacious works of Paul Klee, Vassily Kandinsky, Lyonel Feininger, Gerhard Marcks and others – including even the English Vorticist, Wyndham Lewis – had the minuscule local art world gasping with wonder; it had come face to face with *real* modern art. The terms 'pure painting' and 'painting without a subject matter' had entered the vocabulary as artists and critics alike bemusedly tried to fathom their meaning.

In 1929, when he was nearly seventy, the grand old man of letters, Rabindranath, took to art. An inveterate doodler, Tagore began to see lurking in his scribbles creatures and landscapes of another world. He launched himself upon a full-length inquiry into their nature in what turned out to be an odyssey of a strange and marvellous kind, throwing up at every step images which link man to the primordial in a harrowing way. His pictures are populated with dark creatures from an invisible

underworld or they are about haunting landscapes in searing colours. There cannot have been many instances in the history of art when a man with so many wonderful visions as Tagore, in the twilight zone of his life, began to conjure up weird, wonderful pictures from the depths of his fanciful mind and troubled soul. Much has been written about this phase of Tagore's very long and productive life. All that we can add here is that he concluded it with a wealth of imagery which will puzzle and delight the world for a long time to come.

The year Tagore took to painting in his private study in Shantiniketan, the daughter of a Sikh aristocrat, the beautiful sixteen-year-old Amrita Sher-Gil (1913–41), sailed with her Hungarian mother to France to study art in Paris, first at the Grande Chaumière under Pierre Vaillant and subsequently at the Ecole des Beaux-Arts, where she was taught by Lucien Simon. Though she wanted to imbibe the air of the leafy boulevards of the French capital and sample its inimitable café life, this young woman would return to India in a few years' time and go on to become India's first and most famous female artist of the century. Emancipated, yet responsible, fun-loving but serious, assertive yet fragile, she provided a role model for women artists of future generations. Meera Mukherjee, Mrinalini Mukherjee (daughter of Benode Behari), Arpita Singh, Arpana Caur, Anjolie Ela Menon, Nasreen Mohamedi, Gogi Saroj Pal, Trupti Patel and Rekha Rodwittiya, to name a few, owe much to her. She had carved a niche for herself as an artist, not only through the sheer vitality of her art, but also through the force of her personality and manner of her liberated lifestyle which anticipated feminism by three decades. In fact, the next chapter in twentieth-century Indian art belongs to her – even though new work was being made in the Kala Bhavan under its caring mentor, Bose, it was being done rather quietly, mostly by Bose's junior colleagues, the dynamic Vaij and the contemplative Benode Behari Mukherjee. (The former was forging his uniquely expressive style to portray in cement the downtrodden peasant and tribal folk. But the latter would not start work on his great mural in Shantiniketan for another eight years.)

On the whole, the 1930s saw nothing more remarkable than the work the Tagores had already achieved or for which they had been responsible. Rabindranath's outpourings were those of an individual, the products of an old man's solitude, unrelated to the world outside; his later work became repetitive. The dynamism had dissipated from the Bengal movement. It had, no doubt, served a very useful purpose by spearheading the new and necessary consciousness, but it had outlived its time. One of the reasons for its decline was its elitist nature. (It is an interesting fact that most leading artists, from Ravi Varma and

the Tagores to Sher-Gil, came from the Indian aristocracy.) Perhaps it had to be elitist – it could have only been initiated by the *bhadra lok* who had the necessary financial muscle power, social standing and Western education.

In the 1930s, as storm clouds once again began to gather over Europe and the Nazi menace loomed, India found itself in the grip of a now formidable struggle for independence not for one, but two free countries – the new word 'Pakistan' had cast an undreamed of shadow on the future unity of the country.

Sher-Gil returned to India at the end of 1934, not yet twenty-two, but already a technically accomplished painter, equipped with some of the most essential ingredients that make artists great – an unquenchable thirst to *know*, a virile tenacity of purpose and a single-mindedness about her role in life. Sher-Gil sought to come to terms with her Indian heritage – being only half Indian, she must have known that she would never have an insider's view of India or be able to claim a full share of its psyche. Nor could she exult in its discovery as a complete outsider as Gauguin (whom she admired and whose influence in her work she readily acknowledged) had in Tahiti. This was to introduce into her work certain contradictions which, instead of weakening it, rather added to its strength, charging it with a dynamic tension.

While still a student in Paris, she wrote in a letter how she 'began to be haunted by an intense longing to return to India, feeling in some strange way that there lay my destiny as a painter.' This was a remarkable statement for a twenty-year-old half-Indian woman, however westernized, to make in 1933. In those days, women of her background did not have vocations or careers; only lower-working-class women had jobs, and they were menial. Few Indian girls had an advanced education of any nature and those who did never took up a profession or employment, let alone declared their independence in such an unusual way as by becoming an artist. By her age, most women had been relegated to wedlock through the normal channel of an arranged marriage, and many had borne a couple of children. It may be that a casual remark by one of her Beaux-Arts tutors about her palette being more suitable for the colours and light of the East – as has been suggested by her nephew, the artist Vivan Sundaram – was all that it took to impel the impressionable girl, barely out of her teens, to long to hasten 'home'.

Sher-Gil's statement was a powerful indication of her intent, revealing the passion and the fire behind it. And, upon her return to India late the following year, she lost no time in getting to grips with her ambition. In Paris she may have been thirty years behind the European art movements and current trends,

as hinted at by Sundaram, but she was certainly as many years ahead of her time in India in the mid-1930s – only in the 1960s did Indian artists begin to display her kind of self-assurance and purpose.

She went to live in Simla, the fashionable summer capital of the Raj in the Himalayan foothills, where her liberated lifestyle caused a stir. She began painting poor hill people who, to her romantic and naive mind, embodied the spirit of India. She gave them large doleful eyes and vacant stares, exuding an expression of utter hopelessness. Her lanky and angular figures shrouded in homespun materials look fragile and melancholic, reflecting, perhaps, an inner melancholy of her own. She undertook a cultural tour of India and was bowled over by the freshness and originality of Ajanta and Ellora, the sensuous murals of the Mattancheri Palace in Cochin and the strength of the Kushan sculpture which she saw at Mathura. She became acquainted with Indian miniatures and fell in love with the intense Basohli school. She even attempted to include certain elements of Rajput painting in her later work, doing so with feeling and flair and avoiding Abanindranath's sentimentality. The compelling body of work she left behind makes it unnecessary to regret what more she could have achieved had she lived longer than her twenty-eight years. More than half a century after her untimely death in 1941, she is still admired and held in affection.

Sher-Gil has been accused of neither having any political awareness, nor identifying with the national struggle for independence which was entering its final phase during her last years. Tagore, too, was similarly accused, but he shrugged his shoulders. The only artists to reflect on the Indian tragedy of 1947 were the well-known Indian painter, Satish Gujral (b. 1925), and the little-known Pakistani artist, Tassadaq Sohail (b. 1930). Yet Sher-Gil proved her abiding love for India, to which she only half belonged (she was not even born there), through her identification with its soul. She knew the strengths of the Indian creative genius and the weaknesses of contemporary India. What, perhaps, she did not know was that she would not live long enough to see how soon these strengths would rejuvenate Indian art.

The turning-point came six years after her death with the founding in Mumbai of a group of artists as free-spirited and self-absorbed as herself – the Progressive Artists' Group.

1947, A Turning Point

It is generally accepted that modern Western art dates from 1863. The venue for this portentous birth was Paris, then the glittering cultural capital of Europe, and the occasion, the controversial Salon des Refusés at which Edouard Manet first exhibited his epoch-making *Déjeuner sur l'herbe* to a shocked public. This exhibition has since proved to be one of the most important of all time. In many ways, it ushered in new trends by emphasizing alternative views about the purpose and practice of art, cutting through the stifling atmosphere which had prevailed until then in French academic circles. It claimed a new role for the artist in a rapidly changing urban society whose affluence came from the benefits of the industrial revolution. Henceforth, rather than following rules dating from the Italian Renaissance, artists would paint the world as they saw and experienced it. World art was set to change forever in ways Manet and his recalcitrant contemporaries could never have imagined in their wildest dreams.

If a moment has to be singled out when it could be said that modern art in India took off in a purposeful way, though on a humbler scale, it would have to be 1947 when Britain finally let India go its own way and, in the words of its first prime minister, Jawaharlal Nehru, keep its 'tryst with destiny'.

The turning-point of 1947 is chosen not for political reasons, nor for reasons of its historic importance to India and its future as a sovereign state, but because in that year a twenty-three-year-old former member of the Communist party, of modest origins, unassuming appearance and meagre means, the Goan-born F. N. Souza (b. 1924), founded the Progressive Artists' Group in Mumbai. The group had five other members – M. F. Husain (b. 1915), K. H. Ara (1914–85), H. A. Gade (b. 1917), S. K. Bakre (b. 1920) and S. H. Raza (b. 1922). While Husain would emerge as the towering figure of twentieth-century Indian art and its most successful protagonist, at the time of the group's formation it was young Souza, the most articulate and daring of the six, who was the driving force. Their manifesto, drawn up by Souza, was summed up in the word 'progressive'. Souza has written that 'the root of the word progress, "pro" means forward, and that is where we wanted to go.' Going forward meant, among other things, rejecting the hackneyed nineteenth-century English art school education and escaping from the small-time values of the puny Mumbai art world. 'We had clearcut views on art, what it was and what it should be.' What it

should be they had yet to prove. And whatever it was, it had place neither for Sher-Gil nor Rabindranath Tagore. Uncompromisingly, the group rejected outright the work of the former as being 'hybrid' (though she was not trained at an English art school) and derivative of Gauguin. Rabindranath was likewise and equally rashly pooh-poohed. Perhaps he was regarded as being too self-obsessed, with his over-emphasis on the inner self and the role of harmony and rhythm in his work, and perhaps it was also because he was over venerated in the guru sense of the word. Even Jamini Roy was considered 'too unsophisticated' – bold and colourful, maybe, but crude, lacking the originality and vitality of the Kalighat paintings which inspired him. Similarly, the Bengal School and the products of Tagore's great university, Shantiniketan, and various individuals who became eminent artists in their own right and influential teachers elsewhere in India were, out of what could have only been sheer ignorance, summarily dismissed as 'too sentimental'.

The aim to go forward was indeed a laudable one for committed artists at the threshold of their careers, but there was nothing new or remarkable about it – had not Abanindranath Tagore and the Bengal School set out to achieve the exact same goal? So what made the Progressive Artists' Group special? And what did it really stand for and want when all its members had in common was this collective urge to 'go forward'? In ideological terms, the group wanted to function in a broader context, they wanted to be related to developments elsewhere in the world and make their work truly of the time in a global sense. On a more practical level, its members wanted exhibitions on their own terms, expecting to be able to live off their work and gain recognition from it.

These faultless expectations are, of course, to be found wherever artists live and function, but they were ambitious aims for the times. Then, as now, the sprawling island-city of extremes – beauty and ugliness, great riches and even greater poverty – that was Mumbai was unprepared for the group's twentieth-century modernism, which unapologetically linked itself directly to its European counterparts. In their own, much humbler ways the aims of these artists, like those of the Salon des Refusés half a world away, wanted to express what was important to them in a manner that was also significant. They had realized conclusively that, without allowing their Indian spirit to be subsumed by it, the future of Indian art lay not in its idealized past, but in the model presented by a technologically advancing West. In this way they differed from Abanindranath and the Bengal School, and therein lay their strength. But in their zeal, they naively failed to understand or even be aware that the European artists' modernism was a result of their collective angst and disillusionment caused by two of history's most horrific wars, unleashing

unimaginable horror, mass-scale genocide and man's bestiality to man. The group's own aim was simply born out of the sheer need to be 'modern'.

In 1947, India itself had lived through its own holocaust, the brutal partition of country and people which resulted in the creation of Pakistan. The birth in its second city that dreadful year of an art group had little meaning for the general public, which saw little art anyway. Yet, despite its faults, Mumbai was one of the two most sophisticated cities of the sub-continent – the other being Calcutta. Although it did not have a professional gallery, it boasted an art scene of sorts, comprising a few score individuals and a tiny art market in which paintings were sold and bought for tens of rupees. Many a Mumbai art dealer now reminds us that a Husain at the time could be purchased for 60 rupees (£6 in 1947); some heartening change has come about since then – at the Sotheby's sale of Indian Painting in London in October 1996, a work by him sold for £40,000.

Several enlightened individuals lived in Mumbai in those days, most prominent among them being Mulk Raj Anand, India's foremost art critic and novelist with an international following. With Dr Hermann Goetz of the Baroda State Museum and Rudy Von Leyden, the art critic of the *Times of India*, he was the first to spot the talents and the professional attitude of the members of the Progressive Artists' Group. Anand saw in them, as he had among artists he had known in Europe, a blazing dedication to their art and a fierce determination to succeed.

The group held its first exhibition in 1948, the year in which Mahatma Gandhi was assassinated. It was opened by Anand who made a perceptive speech, making it clear that the group had much ground to cover. He dwelt more on the inherent significance of the event rather than the merit or otherwise of its content, for the exhibition was about giving a platform to a new, not yet fully formed voice.

The group's members had indeed a long way to go. Too many influences were evident in their work – from the Indus Valley Civilization, the erotic sculpture of Khajuraho and Indian folk art, on the one hand, to the works of Impressionists, Fauvists and Cubists on the other. But there was enough force to suggest that these were artists of substance who had the necessary courage to discard those influences and evolve their own coherent style.

Within a decade, three of them went on to prove the point in no uncertain terms. The urbane Raza, painter of lyrical landscapes, found fame in Paris and later emerged as the most distinguished protagonist of the neo-Tantric art which sprouted after the publication of Ajit Mookerjee's book, *Tantra Art*, in 1967.

The irrepressible and eloquent Souza highjacked London with his compelling work, winning praise from all the major English art critics and becoming so successful that in 1962 he could boast, 'I make more money from my painting than the Prime Minister does from his politics'. Husain, the third success story, was the most elusive and enigmatic of the group. He simply carried the Indian art of the next five decades with him – his painting, in fact, is its living history. Raza's mature work became serenely contemplative and pleasing in a calm, beautiful way. Souza continued to defy, taunt and challenge, thriving on his proven ability to shock. And Husain, impulsive, intuitive, spontaneous, brought the Indian villager and his village with all the paraphernalia of its mythical lore to the elegant drawing-rooms overlooking Mumbai's fashionable Juhu Beach and to the Diplomatic Enclave of New Delhi. A romantic *par excellence*, it was he who managed to paint real India, literally walking barefoot to be in constant touch with its soil.

The Progressive Artists' Group admitted more members after the exhibition, but it was not to last very long. Souza left for England in 1949, Raza for France two years later, and the PAG, as the group had come to be known, petered out. Yet it had made a lasting contribution. The remarkable careers of Raza, Souza and Husain comprehensively confirm the success of the group's concept of modernity – even if it had been inspired by Western modernity and proved prosperous perhaps because of it. Above all, its members had adopted a highly professional attitude in terms of their own creativity and their relationship with the world. This, perhaps, was the group's main contribution to Indian modern art – crystallizing this attitude. It would be inherited by the next generation of artists who followed in their footsteps.

The scene was now set. Indian art could march forward for the next fifty years, liberated from a whole range of debilitating complexes and uncertainties, transforming itself into one of the most vibrant art scenes in the world.

Shifts of Emphasis

Experimentation and the quest for identity continued after the demise of the PAG, but it now became a quest with a difference. By the 1960s, Indian artists were no longer apologists. They saw no shame in borrowing the tools of Western art to forge a new visual language – had not Europe and America washed their hands of 'tradition' long ago, and were they not, likewise, searching, adrift? This was a time of flux. The 'medium' had become the 'message', in the words of Marshall McLuhan. Pop art and Op art were dazzling the capitals of the West with their vacuity; soon there would be instant art and 'happenings' in fancy galleries. Artists would smear naked models with paint and roll them on the canvas while an admiring invited audience, not to mention the perceptive critics, would bestow rapturous applause on all concerned.

Nothing so extravagant, alas (or, perhaps, fortunately), happened in India. But what did happen there was, nonetheless, a kind of quiet revolution, forging individual styles, bringing to the fore new talent and new ideas. On the scene emerged artists of substance such as Satish Gujral (b. 1925), Tyeb Mehta (b. 1925), Krishen Khanna (b. 1925), Ram Kumar (b. 1924), V. S. Gaitonde (b. 1924), Akbar Padamsee (b. 1928), Laxman Pai (b. 1926), Jahangir Sabavala (b. 1922) and a host of others. In 1950 the Indian government established the Indian Council for Cultural Relations for cultural exchanges with the rest of the world. The National Gallery of Modern Art was created in 1954 at the Maharajah of Jaipur's palatial Lutyens-style mansion in Delhi. The same year, under the watchful eye of a committee of nine artists including Bose, Chaudhry and N. S. Bendre (1910–92), a national academy of art, the Lalit Kala Akademi, was set up in the heart of the Indian capital. Exhibitions were regularly held in its spacious galleries together with a prestigious annual national exhibition and the Delhi Triennale. The Lalit Kala Akademi began to publish India's second serious art journal alongside *Marg* (which had first appeared in 1946, edited by Anand), widening art debate and involving more artists and writers.

By the beginning of the swinging sixties, Delhi and Mumbai, which back in 1947 did not have a single professional art gallery between them, boasted several sustaining the increasing number of artists and selling their work. In 1959 the painter Bal Chhabda (b. 1924) opened Mumbai's first commercial gallery in

its bustling new Bhulabhai Institute, calling it Gallery 59. This was soon followed by Kekoo Gandhi's Gallery Chemould in the busy Jehangir Art Gallery, the Dhoomi Mal and Kunika Galleries in Delhi's fashionable Connaught Place and Kumar Gallery in the leafy suburb of Sundar Nagar, opposite the capital's new plush Oberoi Hotel. Functioning along the lines of any professional gallery in London or Paris, they pioneered the exposure of contemporary Indian art in these two cities, showing the cream of the established artists, including Husain, Raza, Souza, Padamsee, Kumar, Ambadas, A. Ramachandran, Krishen Khanna, Mehta, Gaitonde, Biren De, G. R. Santosh, Sailoz Mukherjee, Krishna Reddy (b. 1925) and numerous other young and up-and-coming artists.

As more private galleries, museums and art centres sprang up elsewhere in the country, a lively current of artistic activity came to life creating a palpable atmosphere pulsating with debate, discussion and the exchanging of ideas. The art school in Baroda, energized by visionary teachers such as Subramanyan and Chaudhry, also began producing a steady flow of new talent. More and more artists started to travel abroad for study. Gulam Mohammed Sheikh and Vivan Sundaram both studied in London – the former went to the Royal College of Art in 1963 and the latter to the Slade School of Fine Art three years later. They were followed by a stream of gifted artists such as Mistry, Ranbir Kaleka, Rodwittiya, Trupti Patel and even Geeta Kapur (who has emerged as the most important Indian art critic in the last quarter of the century) who went to the Royal College of Art in the 1970s to be taught by the formidable French painter, Peter De Francia.

In the 1960s, Indian artists travelled regularly between the leading artistic centres of Delhi, Mumbai and Calcutta to show their work and now, for the first time, they also began to travel to the Western capitals to try their luck. Two of them, in particular, deserve special mention as their achievements outside their country would have repercussions back home. The first was the outspoken Souza who, as has already been noted, made an impression on the English art scene. He arrived in London a week before the second anniversary of India's independence, on the Portuguese passport which he was entitled to, having been born in the still-Portuguese enclave of Goa. Armed with only his talent and a certain ability to write, the eager, penniless young man was nonetheless full of optimism. London, still in the grip of post-war rationing and other privations, had no art scene to speak of and it held little hope for a diminutive Indian artist with a pock-marked face. It became shockingly apparent early on that he could not support himself as an artist in this deeply depressed and largely indifferent city.

Souza spent his time attending drawing classes at the Central School of Art and painting furiously, visiting galleries, making friends and waiting for a break. But success did not come easily and it was not until he made the acquaintance of the poet and editor, Stephen Spender, in 1954 that the turning-point came. If the poet was stunned by Souza's forceful oil paintings of tortured human beings and landscapes convulsed with turbulence, the editor in him was bewitched by his writing which revealed a tormented soul torn to shreds. The same year, in his magazine *Encounter*, Spender published Souza's brilliant article 'Nirvana of a Maggot' to wide critical acclaim. This coincided with a sell-out exhibition at Gallery One, one of London's most avant-garde galleries. Souza became an overnight sensation. Successful exhibitions followed and every major critic wrote glowingly about him. He prospered for some time, but his success did not last long. The prolific artist had worked himself into a cul-de-sac from which he never emerged. The quality of his work declined as his personality grew more difficult, gaining him more enemies than friends among the critics. By 1967, London held no allure for him and he moved to New York, where he fared little better.

A strikingly similar pattern of events was experienced by another great Indian artist, Avinash Chandra (1931–91), who came to London in 1956 and became critically and commercially as well known and successful as Souza. Chandra had a towering personality and was sometimes seen, mistakenly perhaps, as arrogant. His career, like Souza's, did not improve on moving to New York. He died in London, to which he had returned in 1978, a disillusioned man.

More original than Souza, Chandra lyrically encapsulated in line and colour the spirit of Khajuraho, India's love songs and its time-revered appreciation of physical love. He worked intuitively, Klee-like, with Miroesque bravado. His subtly erotic coloured ink drawings – fresh, powerful, unique – made W. G. Archer, doyen of the English establishment and the Keeper Emeritus of the Victoria and Albert Museum's Indian section, declare, 'his pictures with their ardent colours, taut rhythms and poetic images are perhaps the strongest proof we have that Indian painting can be vitally modern, yet through these very qualities, remain deeply and traditionally Indian.'

Chandra, like Souza, had exhibited widely in the West, but unlike him, Chandra had not shown in India since 1956 while Souza had continued to exhibit there periodically, in Mumbai and Delhi, to keep in touch with home. During his lifetime, Chandra showed only once in India, jointly with Balraj Khanna (b. 1940), at the invitation of the Indian Council for Cultural Relations. The exhibition was held at the

Lalit Kala Akademi, Delhi, in January 1983 with introductions in the catalogue by the eminent English critics Dennis Duerden and Philip Rawson. It was the first time two Indian artists who had settled abroad were accorded official recognition in India, a clear indication that the country had begun to take its contemporary art seriously.

Effulgent Chandra, with his straightforwardness, and brash Souza, with his powerful writing, were among the most sought-after artists in London during the late 1950s and early 1960s. In 1962, the celebrated critic Edwin Mullins published a laudable monograph on Souza and in the same year, BBC television made a brilliant film on Chandra with an informed commentary by W. G. Archer.

While these prestigious events considerably enhanced the reputations of the artists concerned, doing no harm to their sales in the process, their effect back home was not inconsiderable, demonstrating to the indigenous art scene that contemporary Indian art had a role to play on the international stage. Souza and Chandra may not have stylistically influenced the work of any Indian artist, but their dedication to their art and their phenomenal success in a country which had ruled India for so long, and which habitually negated the merits of Indian art, had inspired many. They had evolved their own idioms, however different from one another, and set an example. It would be emulated.

Individualism

An artist of the time who resisted going west in search of fame and fortune, yet found both in a more substantial and durable way was the indefatigable Husain. Mixing in his cavalier manner the village, the tribe and the town, his work had caught the imagination of the nation from his PAG days and it has remained fascinated by him ever since. While the successful artists of modern times all came from middle-class backgrounds, Husain alone hailed from a traditional artisan community in central India – his grandfather was a tinsmith. Having lived with his own family for years in abject poverty in a Mumbai hovel, he had experienced at first hand the irredeemable misery of such lives. A native of the feudal city of Indore, where he attended art school for six months, Husain painted film sets and cinema

hoardings in Mumbai for several years. He was working for a furniture manufacturer when Souza 'discovered' him after one of his paintings won a prize in the 1947 Bombay Art Society exhibition.

The story of Husain's amazing success began with the launching of his career at the PAG's exhibition in 1948. So rapid was his rise that by the mid-1950s he had become a national celebrity. That celebrity status has remained, with exhibitions of his work worldwide – he starred with Picasso when the two of them were given one-man shows in 1971 at the Sao Paulo Bienniale – accompanied by unabating media attention in India. Looking back, it would appear that India needed Husain as much as he needed her, for no Indian artist has captured her soul so poignantly or so vigorously.

Husain's appeal to Indians lies in the fact that he, more than any other artist, is so very much in touch with Indian realities, at every level. His work is raw, yet vibrates with warmth; full of pathos, it brims with natural exuberance; it is full of contradictions and full of marvels. His success is a result of his being intuitive and being in tune with the pulse of a society which functions on so many contradictory levels. His folk are tied to the earth, but it is Indian earth. Although not of the lowly stock himself, he knows his peasants well and turns them into noble beings.

Husain is a shaman who knows what signs and symbols to paint, where to put a hand, a child's toy, a village lantern, and where a snake, a spider, a tiger – all living signs of Indian folk culture, as easily understood by a millionaire mill-owner of Ahmadabad as by his retinue of retainers, all of whom come from rural India. At heart, every Indian, no matter of what caste or class, is numinously and directly linked with the Indian earth, which from time immemorial has spawned its legends and rituals, its gods and goddesses. A Muslim, Husain paints Hindu mythology, purposely avoiding his own. But the gods and goddesses and the rituals he portrays are no less real nor lacking in appeal. A devotee of Urdu poetry and Indian classical dance, he infuses his imagery with the cadences of the former and the rhythm of the latter. His repertoire is varied – he paints toys with the wonder of a child and from his horses emanates the energy of galloping stallions. He has been accused of being repetitive and publicity conscious, but were not some of the leading European artists of this century equally so? One negative aspect of his work is that for all his virtuosity and playfulness, he places his folk in what could be called a static culture. Indian culture is anything but static.

If modern Indian art really began life in the year of its independence, 1947, it entered its next and more crucial phase, that of consolidation, in the 1960s as artists strove to evolve individual styles. The

PAG had not truly opened up any new directions nor offered a panacea to artists struggling to find their identity – all it had done was to articulate a voice and sublimate an inner urge to come to terms with that struggle. Although an achievement in itself, it could become productive only if the necessary attitudes evolved along with that struggle or as a result of it. For that alone could translate that voice, that urge into the reality of work. The 1950s and the 1960s saw the nation-wide evolution and crystallization of these attitudes and the art scene, more so in Mumbai and Delhi than Calcutta, began to enlarge visibly. In Mumbai's thriving new cultural complex, the Bhulabhai Institute, most of the prominent artists of the day rented studios, working side by side as a close-knit community, informing, influencing and inspiring each other. They were within earshot of Ravi Shankar's music school and E. Alkazi's drama academy, both of which were under the same roof as Gallery 59. The atmosphere throbbed with excitement and the exhilaration of constant creative activity. While in Delhi, the Silpi Chakra Group had been organizing more regular exhibitions and other cultural events, enlivening the scene there.

Modern Indian art was coming into its own, yet there was still no substantial change in market forces and art cannot survive without patronage. In a country that had been independent for less than a decade and a half and was in the thick of the never-ending and desperate struggle of feeding, clothing and housing its teeming millions, this was indeed a problem.

The 1950s was heralded by India declaring itself a republic in January 1950. Prime Minister Jawaharlal Nehru astutely decided to remain within the Commonwealth, an imaginative move which would inspire other former British colonies as they moved down the road to independence. In 1955 at the famous Bandung Conference of the free countries of what is now termed the Third World, India engineered the emergence of the non-aligned nations as a third block in world affairs with Nehru at its helm and Gamal Abdel Nasser of Egypt and Kwame Nkrumah of Ghana by his side. This brought India world-wide prestige and gave Indian intellectuals greater confidence to shape the destiny of their young nation. A determination to rebuild India – socially, culturally, economically and technologically – was in evidence, and a wealth of enthusiasm available. Great projects were undertaken to improve agricultural produce and industrial output – massive dams were built to generate more electricity and provide controlled irrigation; extensive land reforms were put into operation, as were immense industrial ventures. Though India did not have at its disposal enough economic resources to finance these marathon undertakings, the will and energy to build India anew were there, and Indian statesmanship proved skilful enough, even in the era of

the Cold War, to procure scientific and technological assistance from both Russia and the West. These were heady days for India, and the air was charged with euphoria and hope. It was against this optimistic backdrop of a nation united by the will to forge its way forward that the new wave of artists, painters and sculptors emerged. Thus far, the development of art in India, unlike in the West, had been haphazard and lacking in continuity. Changes up to now, whether in form, ideology or methodology, had been dependent on the artists' personalities, their whims, particular interests and attitude of mind, but one vital aspect of art practice in the country had been established – Indian artists had imbibed the ethos of modernism which rested in creative freedom and individuality. It was now a question of sticking it out, going on regardless – sales, it was hoped, would come.

In the absence of a commercial system of galleries and dealers, few artists at the time could make a living from their work. Most came from a middle-class background and some had middle-class professions. For example, Bhupen Khakhar (b. 1934) was an accountant, while Subramanyan and the sculptor Chaudhry both taught at the Baroda Art School. The buyers of their works were still largely either the foreign diplomats in Delhi, Mumbai, Calcutta and Chennai, or the big commercial houses, for instance, the Tatas and the Birlas, and the state-owned airline, Air India. But there was a section of the educated middle class, though lamentably small, that bought paintings from time to time, such as Homi Bhabha in Mumbai, head of India's Atomic Energy Commission. As the great schemes slowly began to bear fruit, as the economy improved a little, commerce started to flourish, the middle class expanded and more paintings were sold.

Indian art of the 1950s and 1960s was essentially experimental, but in a self-assured sort of way, as if the Indian artists had intuitively understood their relationship with the times. When we consider the 1955 painting by Mehta of a giant bull all trussed up and lying helplessly on the ground, we realize that the artist is making a poignant statement with a reverberating message. It is India we behold, at once a giant tied up by forces beyond its control, while at the same time a powerhouse of latent energy and strength.

Mehta was and remains one of the most original artists of his generation. His early work was done in the expressionistic manner of the Progressives, notably Souza, and during his stay in Europe (1959–64), mostly in London, he continued to paint portraits of lonely figures haunted by a persistent melancholy in sombre colours. Perhaps they reflected his own loneliness and alienation in the bleak winters of an England still in the grips of war-time privations.

From the mid-1960s, there was a significant change of mood in his 'falling' figures. The mood of his palette changed too. Brighter and lighter colours appeared, although the pictures still exuded an air of foreboding, of helplessness, of being forced to surrender by an inexorable force. As his style matured, Mehta hit upon a simple device to articulate freer expression and achieve dramatic effect – he cast his boldly outlined figures, sometimes screaming and hysterical, intertwined and emerging out of each other and merging with one another, against flat geometric surfaces like screens. Often powerful diagonals cut across the canvas, reminiscent of the way the sixteenth-century Mughal painters charged their pictures with boundless energy, as for example in works like the *Hamza-nama* (also known as the *Romance of Amir Hamza*), with action proceeding diagonally.

Sharing Mehta's concerns was Gujral, perhaps the most complex artist of the era and also the most versatile. Undeterred by the handicap of a serious hearing problem, Gujral laudably and successfully tried his hand at practically everything to do with art. Born in the same year as Mehta, Gujral is a typical Punjabi – confident and pleasant – and is in complete command of his creative faculties which he continually stretches to their limits. He had had a character-forming political grooming in his early days when both his parents had spent periods of time in British jails during the struggle for India's independence. His early work depicted the Indian tragedy which he had lived through in the Punjab in 1947. Then followed a fortuitous period of apprenticeship in mural-making in Mexico under one of the great exponents of the art, David Alfaro Siqueiros. The *thinking* artist had become a most productive polyglot; the painter with an innate proclivity for creating elemental forms in the 1970s turned to sculpture, with compelling results.

Gujral's sculptures, whether in wood or metal, encapsulate concentrated power and mystery, yet there is also something about them which is primitive and fundamental. In accordance with the ancient Indian tradition that saw an artist essentially as a craftsman – a painter, sculptor and architect – Gujral has more than fulfilled this role. His public murals were not painted like those of his great Mexican masters, but were made in ceramics, using a technique which he determinedly taught himself using a kiln that he had constructed in his kitchen. His life-long love for architecture began to blossom early in the 1980s. The buildings this Renaissance man designed, notably the Belgian Embassy in New Delhi, have attracted controversy and acclaim. Gujral's long and crowded career continues to delight and amaze everyone.

Perhaps the only other sub-continental artist to concern himself directly with the Indian holocaust of 1947 was Tassadaq Sohail. Also a Punjabi, he was born in Julundar where he witnessed unspeakable sectarian horrors when he was only seventeen. Traumatized, he moved to Pakistan with his family after Partition that year. A quarter of a century later in London, his home since the early 1960s, he began to depict the senseless barbarity of the event in small, yet powerful pen-and-ink drawings. A self-taught artist, Sohail's early work consisted of haunted ruins and spires composed of ghoulish figures and skeletons (remains of butchered bodies that he had seen littering the streets of his birthplace during the days of terror), first seen at the Horizon Gallery, London, in 1987. In his later paintings in oils and watercolours, Sohail displays an acerbic wit as he lampoons the all-powerful mullahs of Pakistan who hold sway over its innocent country folk.

Two other painters shared the doubts and fears of these artists in equally authoritative, though individual ways. The early oil paintings of Kumar from the mid-1950s depict human figures in utter isolation. Reminding us vaguely of Sher-Gil's characters, though lacking their warmth and depth, these melancholic figures are sometimes huddled together as if bound to each other by a shared hopelessness. Then we notice, staring at us blankly, harassed-looking men, who could be unemployed office clerks, in a totally mute city or a city deliberately depopulated.

It is not solitude we feel in Kumar's paintings of this period, but a pathetic loneliness – he even titled an award-winning painting *Sad Town*. Perhaps he was reflecting the sorrow, the loneliness and the alienation of hundreds of thousands of refugees displaced from Pakistan in 1947 among whom he was living at the time in Old Delhi. However, the mood of his work changed dramatically when he began painting semi-abstract cityscapes inspired by Varanasi (formerly Banaras) on the banks of the Ganges, the 'eternal city', India's spiritual capital. Geometric forms and shapes representing habitations and places of worship are coaxed together, making the pictures look compact with an almost sculptural feeling. His later, more abstract and liberated landscapes of the snowy perches of Ladakh acquire the grandeur and majesty of the Himalayas.

A little younger than Kumar and a great admirer of his, A. Ramachandran (b. 1935) carries human misery to the extremes of almost holocaustal irretrievability. Although he has done a complete volte-face recently, his oil paintings of the 1960s and 1970s were obsessively devoted to the depiction of headless, naked bodies, reminiscent of the walking corpses of Nazi concentration camps. But Ramachandran's

figures do not inspire pity, horror or anger at the barbarians responsible for an unbelievable crime, instead, they induce revulsion. His is a vision of hell populated by these anonymous beings, sufferers from an unspeakable disease which denied them at birth the human head, giving them only the limbs and a body engaged in macabre rituals and exchanges with each other.

A product of Shantiniketan, Ramachandran says his first picture of man was developed in 1957 in the hovels of Calcutta. One sultry summer day he saw in the gutter his 'first Christ-like image, stretched out naked, drinking the murky water of the sewage'. A few years later, by which time he was a professional painter, he continues, 'I first encountered the monolithic image of the scavenger woman near the public toilets, pushing her wheelbarrow full of the garbage of this beautiful city. Her veiled face transformed into a drainpipe ready for an underground sewage connection. This image of the veiled woman appeared as a motif pushing out the body of Christ in a wheelbarrow.' Morbidity continued to haunt him and became the basis for his sometimes very wide oil paintings. These deeply disturbing works had, nonetheless, a touch of satirical black humour about them.

Ramachandran has described a complete about-turn in his recent works which have become far more optimistic, probably a good thing. Highly decorative watercolours which are unashamedly celebratory in mood, his paintings contain a refreshing cocktail of influences. Modelled on Rajput painting, but not as seductive and effusive, they have rigid structures and an Art Nouveau patterning. They depict certain mythological themes, with the artist himself often featuring in them, sometimes with the body of a bull or a fish. Mercifully, their mood is quite different.

Another compelling artist of his generation who also delves into the unconscious is Ganesh Pyne (b. 1937). His paintings are on a small scale, sometimes the size of a postcard – he could well be called a miniaturist, but one distinctly influenced by a century that has witnessed history's worst violence. His work is embedded in the mystery surrounding his native Bengal's most celebrated, revered and feared mythological figure, the great and awesome Goddess Kali. Pyne digs deep into the unconscious, as Tagore had done, conjuring up imagery from the deepest regions of the mind. He sets his figures and forms in dark hollows of weather-beaten tree trunks (like those used to this day all over Bengal by devotees of Kali who place black stones daubed with red paint in them). The figures are suffused with a gentle light which makes them pulsate against the dark background, intensifying their appeal. It was a device used by artists of the school of Abanindranath Tagore, though without achieving Pyne's depth. Pyne also uses

straightforward imagery which is equally and savagely effective. The cruel-looking old woman in a 1993 painting, *The Dancer*, wears a deathly shroud and holds a sharp dagger in her left hand while a white dove flutters above her right. This spectacle, macabre and mysterious, leaves the viewer wondering whether she has just released the symbol of peace which she had intended to slay, or is indeed just about to do so? In the early 1990s, India was emerging from the most violent period of its recent history – is the artist making a statement about the fragility of its peace since the dove is still within the dagger's reach? Pyne, weaver of mystery and enigma, is in a class of his own.

Also in a class of his own is Padamsee. The son of a successful, self-made businessman and follower of the Aga Khan, the spiritual leader of the Ismaili sect of Muslims, Padamsee became an artist with 'divine sanction', as it were. When he was in his teens, his mother sought the Divine's permission for him to adopt this precarious profession, so uncommon at the time. Permission was duly granted, charging the quiet youth with a sense of destiny, giving him a mission in life.

Padamsee did not disappoint. Although he never joined the PAG, even after it had grown in numbers, he has remained – along with Souza (with whom his early work had something in common), Husain and Raza, all leading pioneers and stalwarts of the Indian modern art movement – at the forefront for four decades. For much of his life his work has remained resolutely of the Paris School. He went to the French capital in 1951 and lived and worked there for over fifteen years. In his formative period, he used Souza-like bold black outlines to paint forlorn figures given to a quizzical introspection – perhaps this was a result of his keen interest in Sigmund Freud's theories of human psychology. Similarities with Souza exist even in their composition. They were often portraits of 'prophets'. But while Souza, typically, painted Prophets of Doom, Padamsee poured guilt into the faces of his. However, it was in his unforgettable landscapes, sometimes very long cinemascopic panoramas of sweeping vistas – done mostly in shades of grey, and with figures in them – that he proved most effective.

His more recent landscapes are inspired by the philosophic concepts of Kalidasa as expressed in his famous drama *Sakuntala*, the very same work which had inspired Goethe two centuries earlier. Padamsee calls them *Metascapes* in which water is 'the origin of all life, and the sun and the moon as the controllers of time'. Painted in pulsating blues, glowing oranges and whites, suns burn and moons shine on primordial land and seascapes of haunting majesty.

New Horizons

But Indian artists never took to abstraction in a serious way, even though there had been a long tradition of it as demonstrated by the exquisite and highly inventive Islamic calligraphy, and floral and geometric designs which adorn great Islamic monuments such as the Taj Mahal. Husain once said, 'How can I go abstract when there are 600 million people around me in India.' Unwittingly, perhaps, he had spoken on behalf of the majority of Indian artists who had looked on bemusedly from afar at developments in post-war European and American abstraction. Jeram Patel (b. 1930) came to prominence in Delhi in the 1960s with his powerful abstract imagery made with a blow-torch on wooden surfaces and his ink drawings (as did his brilliant protégé, Mohamedi, in Baroda in the next decade with her minimalist drawing), while Vaij in Shantiniketan and Chaudhry in Baroda had already gained considerable reputations with their highly individualistic abstract and semi-abstract sculpture.

Numerous other artists flirted with abstraction and Abstract Expressionism as practised in the West – these included Chhabda and Krishen Khanna. The latter began his artistic career with figuration, to which he returned after an interlude during which he experimented with abstraction, 'this time with a pungent, strikingly effective social and political satire', in the words of painter and critic J. Swaminathan.

Mohan Samant (b. 1926) spent a few years in New York where he came under the influence of American Abstract Expressionism, but by mixing sand, paint and other substances he evolved a vision which was personal, exuding the air of village India. His paintings of the 1960s look like walls in an Indian village with graffiti accompanied by mysterious figures pressed into one another, to which a deft hand has added marks and motifs evocative of the sacred ritual, echoing unmistakably the spirit of Indian folk art. His work may remind viewers of that of the Spaniard, Antonio Tàpies, but Samant is a restless seeker whose imagery has a timeless aspect to it, whether it reminds us of rural India or of West Side, New York.

Indian artists in the 1960s and 1970s, as if out of a collective inner need to be in close contact with India's hundreds of millions, turned in a decisive way towards figuration, believing intuitively that their

destiny lay in that direction; it is a path from which, in the main, they have not deviated. But there have been a number of noteworthy abstract artists, the three most outstanding being Gaitonde, J. Swaminathan (1928–94) and Balraj Khanna. A very painterly painter, Gaitonde constantly experimented with textures and the play of light, which gave his oil paintings a certain depth and brilliance. From the early 1960s onwards, his luminous colours acquired a life and culture of their own, their dynamic infra-structure of layers has since made his work atmospheric. The fluency of his personal idiom marks him out as a master of lyrical abstraction.

On the other hand, Swaminathan, an artist-rebel with a cause, an ideologue, poet, critic, publisher and the founder of a unique museum which brings together contemporary, folk and tribal arts – the famous Roopankar Museum in Bhopal – carried his abstraction into the realm of Indian mysticism, folklore and ritual with resounding success, leaving behind a body of work which is baffling, challenging and enticing. Of the few artists who were also articulate communicators, such as Sundaram and Gujral, Swaminathan was by far the most outstanding. Almost more than through his work, he made a contribution to Indian art through his ability to generate debate about relevant issues. In 1962 he founded the Group 1890 which emphasized the role of intuition, spontaneity and improvisation, ingredients of surrealism more in line with Klee's approach than, say, Dalí's, and ones which were relevant to the exploration of the roots of the Group's members. The Group 1890 (named after the number of the house in an obscure town on the west coast of India where its members held the founding conference) had several artists of substance – Jeram Patel, Sheikh and the sculptor Himmat Shah. But, alas, like the PAG, it did not last long.

The paintings of the third of these outstanding abstract artists, Balraj Khanna, have been likened to those of Klee and Miró. But, according to Alison Beckett of *The Times*, his 'playful surrealism is immediately recognisable as his own, joyous and uplifting', and his symbols representing 'his own lyrical world, his stuff of dreams developed after he came to London in 1962 and taught himself to paint.'

In 1967, Ravi Kumar of the aforementioned Kumar Gallery in Delhi published from Paris one of the most remarkable books on Indian art ever – Ajit Mookerjee's *Tantra Art*. This revealing book embodied the little-known philosophy of the secret cult of the ancient tantrics, a unique mixture of the role of sexual energy and mysticism in the pursuit and attainment of spiritual bliss, relating man to the cosmic principle of existence. When the swinging sixties were at their most exuberant, when the Beatles reigned supreme and 'Flower Power' had perfumed the path of the youth of California, when the capitals of the West

proliferated with emerging 'isms' and styles in art and dramatic changes occurred in fashion, attitudes and thought, the appearance of this book was timely.

What made *Tantra Art* sensational was the astoundingly fresh and modern imagery it contained, as if Klee, Vasarély and Brancusi had had several lives in historic India – even the geometricism of Op art was there to be enjoyed. Inevitably, the world wanted to see examples of this unheard-of and seemingly exceptional art, including paintings, drawings, diagrams and devices, works in stone, metal and wood, in the flesh. While they became available in small quantities soon after this publication at private galleries in some of the leading European and American cities, in an inspired move the Arts Council of Great Britain hosted a major exhibition of these works at London's Hayward Gallery in 1971. Philip Rawson wrote the catalogue introduction to what proved to be an eye-opening exhibition, as the Bauhaus show in Calcutta nearly fifty years previously had been, although on a much smaller scale.

It was equally inevitable that artists in India would respond to *Tantra Art*. They did so with alacrity. Biren De (b. 1926), G. R. Santosh (1929–96) and K. C. S. Paniker (1911–77) tried to capture on canvas in oils and acrylics, using much larger formats, the spirit of what the seventeenth- and eighteenth-century tantric artists had done mostly on a small scale on hand-made paper; they succeeded to an extent. But it was Raza who emerged as the profoundest of them all. The erstwhile painter of graceful and dramatic landscapes of the jungles of his native Madhya Pradesh distilled in his work not only the essence of *Tantra Art*, but also imbued it with his own individuality, lending his work a metaphysical presence. His colours resonate like Rothko's, while the mathematical precision of his geometrical elements have an effect on us akin to the sensation we experience upon coming face to face with a Mondrian – one of absolute harmony – as had been assiduously pursued by his adopted teachers, the Tantric artists of preceding ages. His *bindu*, the dot, is a microcosm encompassing the macrocosm.

Magic in Realism

India fought two short and unnecessary border wars in the 1960s, one with its former friend China in the autumn of 1962 and the other in the summer of 1965 with Pakistan, its enemy from the moment of the two new countries' birth. The latter was mercifully inconclusive, but the former did India a service by revealing its weaknesses as a nation state in the modern world.

Defeat in war is never good for the morale of a country, nor for its standing in the community of nations. Strangely, neither was the case here – what happened instead was that for the first time in its young life as a free country, India felt united as it never had before. And the rest of the free world, especially America and Great Britain, in condemning China's aggression, leapt to its support morally and materially. India had lost the war, but it had scored a moral victory of a sort – China became the villain of the piece. Although it was a personal defeat for Nehru from which he never really recovered (he died eighteen months later), India did not lose its standing in the world. At the same time, a lesson had been learned – India had to be self-sufficient and strong; it had to replace its misplaced idealism with hard realism. It is debatable whether these wars, lost or inconclusive, entered the Indian public's thought-process in a significant way or left a mark on its artistic psyche. But it is a fascinating fact that within a decade (following yet another war in 1971 with Pakistan – with dramatic consequences this time, changing the map of the subcontinent for the second time in less than a quarter of century as Pakistan's eastern wing became independent Bangladesh), the need for realism subconsciously and silently seeped in. Artists all over the country gradually began to address themselves more and more to the realities of contemporary Indian life. Their tendency towards figurative work provided them with an excellent tool to come up with modes of expression unbounded by constraints which had inhibited their recent predecessors.

One of the more remarkable of these artists was Kerala-born Subramanyan. Perhaps the best-known product of Shantiniketan, he became a brilliant theoretician, essayist and craftsman and the country's most influential teacher at the Baroda University which has, since the 1960s, produced a regular stream of gifted artists such as Sheikh, Khakhar, Vivan Sundaram, Mrinalini Mukherjee, Rodwittiya, Mistry, Trupti Patel and many others.

Subramanyan went to Baroda in 1951 and after an impressive career spanning nearly three decades, he returned to Shantiniketan in 1980 as Professor of Painting. An artisan-artist like Gujral, he may not have built buildings, but Subramanyan has certainly adorned at least one large one with a major mural in terracotta, a material for which he has an inherent affinity since it was the first substance early man used to fashion art. Showing promise from an early age, he joined Shantiniketan in 1944 at the invitation of Bose. His personal tutor was none other than Benode Behari Mukherjee, and as apprentices do while learning their trade, he assisted from 1946 to 1948 on the master's famous 100-foot mural of a procession depicting the holy life of saints. While Mukherjee remained his mentor, he found a friend in the redoubtable Vaij, who, besides being the country's foremost sculptor, was also a prolific painter in oils. In fact, Subramanyan's early work is clearly influenced by Vaij's paintings. The teaching ethos of Shantiniketan formed by its well-known creative trinity – tradition, nature and freedom – much impressed the young man and he found inspiration by learning various techniques from professional hereditary craftsmen.

Subramanyan's career as an artist really began in 1955 with a one-man exhibition in Delhi organized by the Silpi Chakra Group. Ever since, he has been hugely prolific and successful, exhibiting nationwide and internationally, teaching, writing, painting. His pictures have a Matisse-like ornamentation with the directness of Kalighat *pats* in a spatial framework comparable to the bewitching eighteenth-century Malwa miniatures. Courtesan-like women often appear in them not only to seduce, but also to tease, provoke and amuse, lending his work a delightful humour. In his irresistible terracotta reliefs there is story-telling laced with satire and the same humour. In his later work, the paintings on glass of the 1980s, Subramanyan works with the light-hearted abandon of the *patuas*, makers of Kalighat *pats*. In between, his mid-1970s *Terrace* reminds us of Pop art, especially of David Hockney in his choice of colours and geometric organization. Of his numerous public commissions, one of the most remarkable is the monumental terracotta mural (1962–63) for a theatre in Lucknow named after Tagore. A mammoth undertaking, it involved 13,000 individual pieces of fired clay which were assembled into a nine-feet (2.7 metre) high and eighty-one-feet (24.7 metre) long spectacle on an exterior wall. Subramanyan has also been an effective champion of the traditional crafts while continuing to be a mentor to a whole generation of younger artists.

One of his many successful pupils was Khakhar, who studied art criticism under him. Born in 1934, Khakhar occupies a unique place in contemporary Indian art – more than any other Indian painter, he has

captured the essence of middle-class urban India. 'Middle-class' in India can assume numerous forms and modes. On the one hand, there is the pretentious 'progressive' middle class which apes the West, or rather, the long-departed English (as far as the Indians are concerned, it was not Great Britain which ruled them for so long, it was England). On the other, there is the middle middle-class which has no pretences, is largely unaffected by external forces and whose members know their station in life. Khakhar makes us see different layers and levels of their existence simultaneously, with their unrelenting love of gaudiness when it comes to the question of good taste of which they remain blissfully ignorant.

Brought up in a traditional middle-class joint-family, Khakhar possesses an unerring eye for detail and an intimate knowledge of the psychology of such large family groups. He extends the life of the joint-family to the street and the bazaar and from there to the town itself. A good number of his paintings are about the middle-class householders, their concerns and preoccupations, which are identical to those of their neighbours. It is about a certain way of life in which calendar gods and film stars, barbers and watch repairers, caste-types and stereotypes all play their designated roles. Khakhar's art has been wrongly called Indian Pop art because there is no Indian equivalent of the West's popular culture (the nearest being its bazaar life with its *paan* booth here, cloth shop there and tea stall nearby, at all of which the artist makes a brief stop on his way to a rendezvous with a friend or to discharge some family obligation).

Khakhar's paintings, even when they are about the most mundane and banal aspects of inner-city Indian life, never succumb to the vacuity which underlines much of Western Pop art. Bewitchingly, they portray people and situations which bring to mind the seductive magic realism of Gabriel García Márquez and Salman Rushdie. In 1995 Khakhar painted a portrait of Rushdie which was acquired by the National Portrait Gallery in London, the first work by an Indian artist to be bought by the gallery. To his immense credit, Khakhar is also the first self-confessed homosexual Indian artist, which in a country still ruled by Queen Victoria in certain ways is indeed a courageous thing to admit.

If the 1960s had been a 'swinging' decade, if only in a modest way, the 1970s did not prove to be soporific either. After the liberation of Bangladesh came the extraordinary news in 1974 that India had become a nuclear power – it had conducted an underground nuclear explosion in the desert in Rajasthan. The following year saw Indira Gandhi's ill-judged declaration of a State of Emergency. Although Indian trains started to run on time, her prized democracy came to a standstill – civil liberties were suspended and the country became a police state. The nation united once again, this time to dislodge Mrs Gandhi

from power. Indian artists reacted, painting pictures on the theme of oppression and holding exhibitions of these works at a time when public demonstrations were prohibited. The Gandhi government eventually fell, but the divided opposition could not hold on to power and Indira Gandhi made a dramatic comeback two years later. Though there was something farcical about the whole episode, the nation's mood remained optimistic and the artists, ever increasing in numbers and now very much in their own stride, continued to reflect it in their own individual ways. In particular, Gulam Mohammed Sheikh (b. 1937) of the Baroda School and the Royal College of Art, London, emanates a magic realism which is entirely his own. He even admits that 'every painting in some respect is an attempt in autobiography ... *vis-à-vis* the environmental context you belong to.' Revealingly, he adds, 'Thus every attempt at painting takes you to roots inherited ... to roots desired,' acknowledging the importance of fantasy in his work. Charged with these convictions, he gives us scintillatingly brilliant colours with the discipline of Mughal painting – a kaleidoscope of Indian life of yesterday and, poignantly, of today. As in Indian miniatures, Sheikh encapsulates a wealth of detail in his paintings which are often sectionalized, revealing dream-like unexpected visions, narratives and incidents in sparkling colour. Luxuriant flora, small-town domestic architecture with arched doorways and meandering streets and more of the town in the background present the viewer with a sumptuous visual feast.

The paintings of the 1970s and 1980s of Vivan Sundaram (b. 1943), also of the Baroda School, give us a glimpse of a master in the process of realizing himself. His work was a storehouse of hidden social meanings and messages and his painted surfaces pulsated with a palpable tension. These oil paintings were memory-collages or palimpsests which made possible a simultaneous view of several situations. Something of a maverick, Sundaram is a man possessed, often changing his style and stepping across boundaries of uncharted territories which he feels drawn to explore, of changing social realities, political and historical pressures.

An energetic organizer of art camps, bringing artists together, even from abroad, he has always been at the forefront of the continuous flow of 'art debate' in India. Perhaps the changes in his style mirror his need to adjust his stance to the fluctuations in its flow – for every serious artist has the right to change his style in order to articulate what cannot be said in any other way.

A somewhat younger artist who also paints in the surrealist vein of Khakhar and Sheikh is Ranbir Kaleka (b. 1953). Born in Patiala, the seat of the former maharajahs of that princely state, Kaleka paints

as if he was not concerned about anything, just having a deep-rooted curiosity about human nature and its sexual fantasies. The only Indian artist to display such uninhibited humour, he paints elaborate phantasmagorias in which the male libido reigns supreme in ways that are overtly funny, as in a 1991 oil entitled *Cock-a-Doodle-do*. Animals, fish and cranes dance about in primordial landscapes in luminescent colours as a hare declares itself 'fecund' before a bizarre audience. Or a spent but otherwise virile-looking youth sits on his haunches in *Family-11* (1993), contemplating a luscious female nude sprawled across a gushing stream, legs akimbo and eyes shut in a post-coital trance. Kaleka paints with verve and wit, but it is raw and wicked – it delights, it dares and it teases. His is a kind of surrealism which will keep students of Freud and Jung well occupied for quite some time to come.

Sudhir Patwardhan (b. 1949), a self-taught artist who trained as a radiologist, made his name by painting life in a small Indian town, giving his canvases titles such as *Town 1984* and *Street Play 1986*. He declared that his aim was 'to make figures that can become self-images for the people who are the subject of my work.' Boldly, and avoiding the risk of distorting the image, Patwardhan painted the town as if viewed from more than one angle at the same time, thus offering more insights into the character of the place. It is a sanitized scene in which the town folk go about the mundane business of life – children jump into a stream from the local hills which runs through the town, and enjoy a swim while a scooter-rickshaw wallah washes his vehicle on its bank. The people look unhurried and the place emanates calm. Patwardhan captures the sense of peace even more effectively in his landscapes painted in the 1990s.

Gieve Patel (b. 1940), a medical doctor by profession and a well-known writer, is also a self-taught artist. He began by painting images from newspaper photographs of dead 'leaders' smothered by heaps of flowers looking equally lifeless and devoid of any fragrance, giving out a message that here lies someone surrounded by as false a glory as his self-serving career had entitled him to, so true of the majority of politicians. Then, unexpectedly, Patel moved on to painting railway landscapes – stations, platforms, railway structures, stark girders supporting weights set in the bleak environment that people in transit have to contend with. An admirer of Padamsee, Patel achieves some of his mystery in his later work of the 1980s and 1990s as he moved, with ease, from an urban locale to a rural environment, placing figures in one and then in the other as the situation demanded.

More puzzling than any other Indian artist is perhaps Jogen Chowdhury (b. 1939). Using ink, pastels and biro pen, he draws well-fed, middle-class, middle-aged men often sitting cross-legged on the floor,

Indian-fashion. His subjects seem trapped in lumpy, putrid and wrinkled flesh so flabby it can be folded over. With their fixed stares and flaccid, phallic limbs, they should emit a feeling of revulsion, but they don't because these mysterious rubbery creatures have something endearingly comical about them. They are grotesque on the one hand, but on the other they have a certain poise, approximating dignity. Chowdhury invests even inanimate objects, such as vegetables or flowers, with the same mystery.

Equally puzzling is Manjit Bawa (b. 1941). Using brilliant colours, he paints gods, men and beasts in situations that charm and amuse. Giving them well-rounded solidity, he sets them against expanding areas of fluorescent colours which resonate – deep reds and mauves and yellows. Often, we see a human figure, a girl, for instance, with a domesticated animal such as a cat or a playful dog. In a 1995 painting titled *Heer and the Goat* we see another such figure playing a flute to a bemused-looking goat with folded skin. One of his works illustrates a well-known Indian pun – a man plays a pipe to a bull in the futile hope of charming it. Ever irrepressible, Bawa displays the same wit and irreverence, even when he paints Indian gods and goddesses.

A New Phenomenon and Young India

The 1970s and 1980s saw something unique – the arrival of professional women artists, some of whom were more gifted than many of their male counterparts. Unlike in the West where feminists united everywhere and questioned male supremacy, justly demanding full equality, this phenomenon in India occurred in a non-confrontational context. Indian women simply wanted to paint and sculpt. They proved to be brilliant and they deservedly received respect for their work. India began to enjoy the exceptional talents of the Bengali sculptors Meera Mukherjee (b. 1923), Mrinalini Mukherjee (b. 1949), the Delhi painters Arpita Singh (b. 1937), who married the remarkable landscape painter Paramjit Singh, and Arpana Caur (b. 1954), the Paris-educated Anjolie Ela Menon (b. 1940), and

Nasreen Mohamedi (who died in 1990, leaving behind a body of astoundingly original minimalist drawings in ink), the Royal College of Art graduate Rekha Rodwittiya (b. 1958) and the Lucknow-trained Gogi Saroj Pal (b. 1945), among so many others.

Indian folk art is deeply indebted to Indian women. From time immemorial, they have decorated doorways, painted walls, made floor designs, embroidered, woven and even painted pictures on paper (the Madhubani artists of Bihar at last found fame nationally and internationally with recent exhibitions of their highly coloured drawings). But historically, there had, until the 1930s, been no female artists where 'high' or mainstream art was concerned. Sher-Gil was the first such artist to emerge, predominantly because she was, though half Indian by birth, totally European in her personality and Indian only in her sensibility. It is doubtful that had she been wholly Indian, born and bred among the wheat fields of Punjab where her father originally came from, she would have been a painter or would have been allowed to become one. Although she had set an example with her exceptional courage and genius, for over a quarter of a century after her death in 1941 there had still been no female artist of calibre. Now, suddenly, there was a growing number of them, giving a new dimension and depth to Indian art, enriching it and winning admirers abroad. Mrinalini Mukherjee's fibre-hemp sculptures, breathtaking and invoking the numinous, won acclaim during her exhibition in 1994 at the Museum of Modern Art, Oxford (where Trupti Patel, b. 1957, had also shown her ceramic sculptures the same year and was warmly received). And Anjolie Ela Menon's saleroom success at Christie's and Sotheby's since 1989 has demonstrated convincingly that female Indian artists have come into their own.

While the women continue to play a leading role in Indian art, there has appeared on the scene a home-grown crop of artists, bringing with them new vitality and vision. Yusuf (b. 1952), Akhilesh (b. 1965), Vijay Shinde (b. 1958) and P. Srinivasan (b. 1951) take to abstraction with a certitude and sensitivity seldom seen these days in the West. Atul Dodiya (b. 1959) in his first appearance in the early 1980s handled light, space and surfaces with the teasing ease of David Hockney on the one hand and Edward Hopper's sharp eye for detail on the other. In his more recent paintings he has fused 1970s photo-realism with a subjective surrealism to come up with autobiographical story-telling. A vastly different kind of surrealism by Surrendran Nair (b. 1956) haunts the eye and leaves the viewer agitated, while Paresh Maity's (b. 1965) vigorously charged watercolours depict conflict between the water, land and sky, and confrontation between man and woman wittily conducted through a never-ending staring contest. The

most intriguing, however, of the younger artists is the sculptor N. N. Rimzon (b. 1957). A thinking man's sculptor, he takes the floor and occupies the wall to let his work, often in several units of seemingly unrelated images, breathe, baffle and challenge the brain.

Two young artists who stand head and shoulders above the others are the sculptors Kapoor and Mistry. Highly accomplished, both have gained international reputations – after representing Britain at the Venice Biennale in 1991, Kapoor won the coveted Turner Prize two years later and was the subject of a brilliant book by Germano Celant in 1996, while Mistry was elected to the Royal Academy at the age of thirty-four in 1991, the youngest academician since Turner. Kapoor came to prominence in the early 1980s with his stunningly original abstract floor pieces in resin, wood and pure pigment, reminiscent of Indian ritual. Tireless and inventive, he dazzled with his later, more daring, yet simple forms hewn out of rock which emanate India's timeless mysticism as well as carry a philosophic content. Mistry, whose work is figurative, achieves the same results with equal panache in metal, stone and wood. His massive winged, Sphinx-like figures with human heads, after the South Indian wooden *Vahanas* (conveyors of the gods), exude power and authority, while his recent reliefs echo the metaphysical culled from Hindu mythology. These square-shaped works have a certain elusive beauty and mystery. His 'masks' made from broken old Indian wooden houseware invoke the primeval as did the African masks which inspired Picasso at the turn of the century.

The Future of Contemporary Indian Art

The 1980s saw India enter its bloodiest political phase since independence. Violent internal upheavals caused by separatist terrorism cost the country tens of thousands of lives, including that of Indira Gandhi. But as history stands witness to it, India has a staggering fortitude and prodigious talent for survival. It survived. Purged of its self-inflicted pain, it emerged with a resounding cry for *ekta*, unity, and a deeply felt need to bring about fundamental changes in its tattered financial system.

The 1990s saw that change with the introduction of an 'open economy', emulating other successful countries in the Far East such as Singapore, Malaysia and South Korea. While the overall effect only gradually spread over the rest of India, in the sphere of art it resulted in a virtual boom – works of contemporary art began to sell as never before, setting an encouraging trend which has helped to create the much-needed gallery structure in the country, spearheaded imaginatively by the Wadhera Gallery in Delhi, Rakhi Sarkar at the CIMA in Calcutta and Pundole Gallery in Mumbai.

Internationally, too, interest in contemporary Indian art is growing rapidly. The great Festival of India in Great Britain in 1982 introduced it to the West in a substantial way through a major exhibition at the Royal Academy of Art similar such festivals have been held in the leading world capitals since then.

The distinguished American collectors, Chester and Davida Herwitz, reputedly the first foreigners to have displayed a consistent interest in the modern art movement in India, with remarkable foresight have acquired thousands of works by Indian artists during the last three decades. The Fukuoka Museum and the Glenbarra Museum in Osaka, Japan, boast of similar collections, and they regularly stage exhibitions of Indian artists living in India and abroad. Galleries specializing in contemporary Indian art are springing up in Western metropolises – London now has a number. The trend began in 1987 with the artists-run Horizon Gallery in Bloomsbury (established under the auspices of the then flourishing Indian Arts Council, UK) and is now continued by the Kapil Jariwala and other galleries in London's exclusive West

End. Auction houses of world-renown, such as Sotheby's and Christie's, while they have been holding sales of historic Indian art for decades, have since 1989 held regular sales of contemporary Indian art in Mumbai, Delhi, London and New York, with mounting success. These sales have attracted collectors from all over the world, demonstrating in no uncertain terms that Indian art has a growing commercial value internationally. While pre-viewing the 1996 Sotheby's *100 Years of Indian Painting* exhibition, the eminent critic and editor, Peter Townsend, remarked, 'these works look very universal, but they could have only been painted by Indian artists.' At home, enthused and invigorated by their success, creative and commercial, artists continue to experiment, evolve and develop, making the contemporary art scene in India among the most vibrant in the world. It is in this atmosphere of optimism that the Indian creative genius approaches the new millennium.

The Bengali Cultural Renaissance

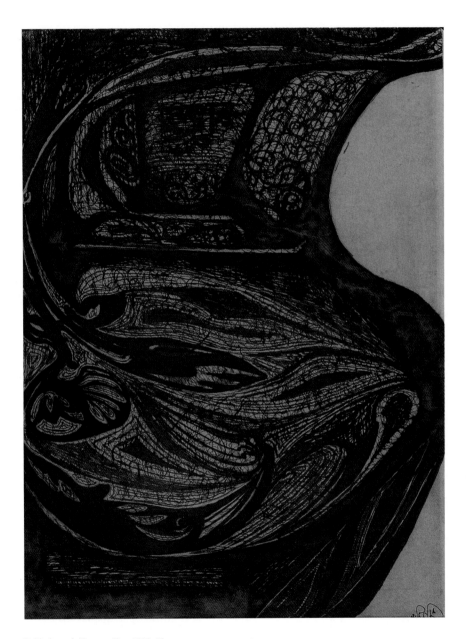

Rabindranath Tagore, *Vase*, 1928–29
Pen and ink on paper
28 × 21 cm (11 × 8¼")

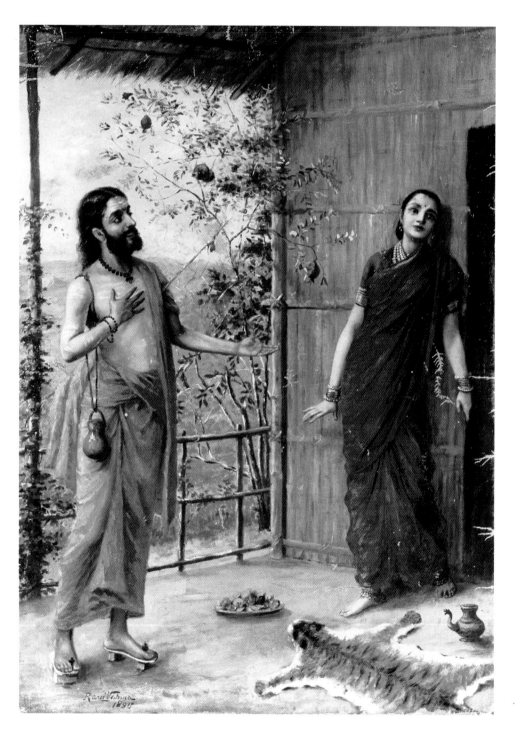

Raja Ravi Varma, *Ravana in the Guise of a Holy Man*, 1895
Oil on canvas
72.5 × 51.5 cm (28½ × 20¼")

Raja Ravi Varma, *Woman Wearing a White Sari on a Veranda*, 1895
Oil on canvas
53.5 × 35.5 cm (21 × 14")

Gaganendranath Tagore, *The Queen of Puppet*, 1926
Gouache on paper
25 × 15 cm (9¾ × 5¾")

Abanindranath Tagore, *Mother and Child*, 1905–09
Lithoprint
27.5 × 18.5 cm (10¾ × 7¼")

The Emergence of
Modern Art in India

Jamini Roy, *Reclining Female Nude*, 1920–24?
Gouache on paper
58 × 36 cm (22¾ × 14⅛")

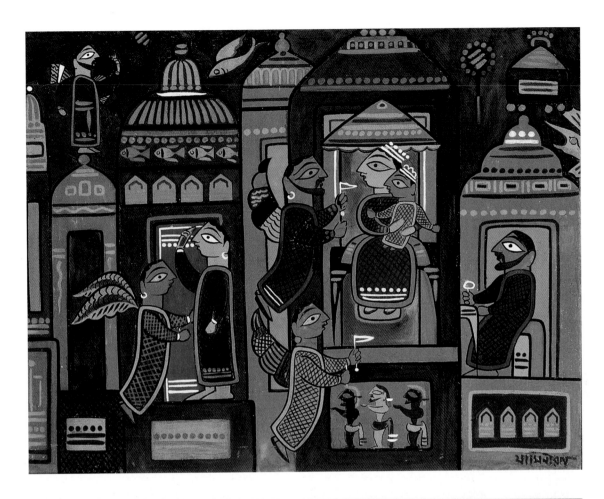

Jamini Roy, *Mother and Child with St John*, 1940–45
Gouache on canvas
71 × 91 cm (28 × 35¾")

Jamini Roy, *Alpana*, 1940–45
Oil on canvas
38 × 76 cm (14⅞ × 29¼")

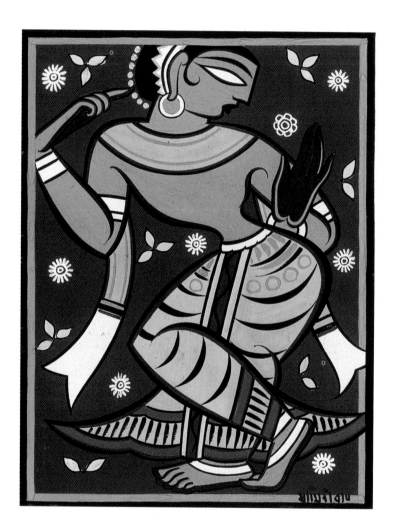

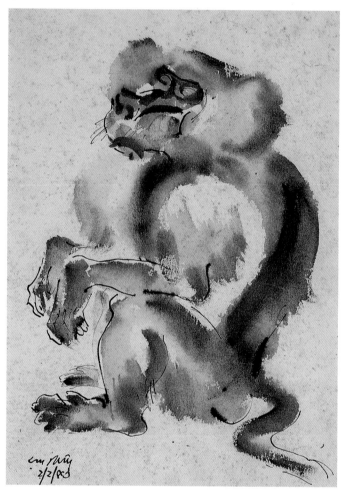

Jamini Roy, *Gopini*, 1940–45
Gouache on paper
56 × 43 cm (22 × 16¾")

Ramkinkar Vaij, *A Monkey*, 1945
Pen, ink and watercolour on paper
43 × 30 cm (17 × 11¾")

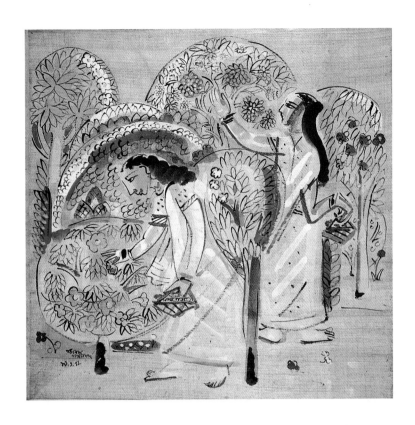

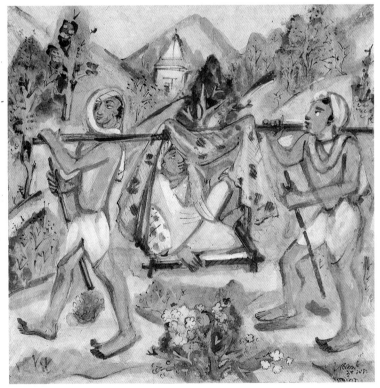

Benode Behari Mukherjee, *In the Garden*, 1948
Tempera on silk
43.5 × 43.5 cm (17 × 17")

Benode Behari Mukherjee, *Doli*, 1948
Tempera on paper
50 × 50 cm (19⅝ × 19⅝")

Tagore and Sher-Gil

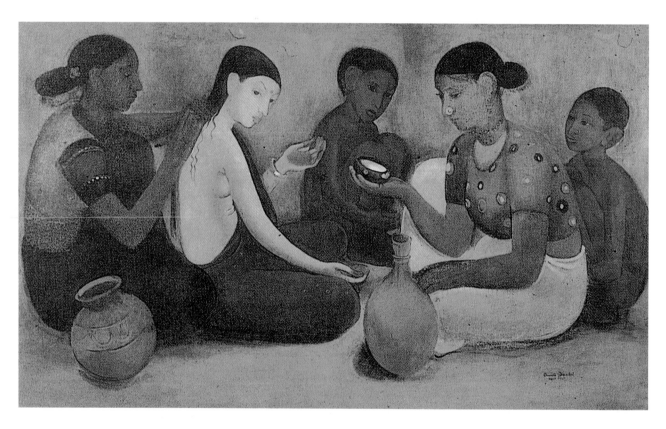

Amrita Sher-Gil, *Bride's Toilet*, 1937
Oil on canvas
86 × 144 cm (33¾ × 56½")

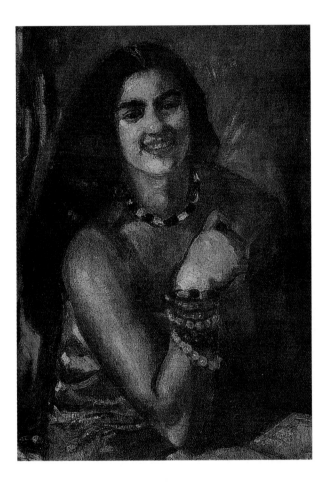

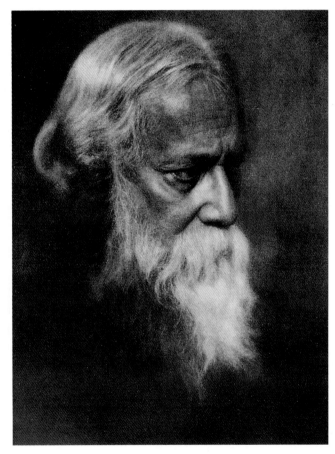

Amrita Sher-Gil, *Self-Portrait*, n.d.
Oil on canvas
70 × 47 cm (27½ × 18½")

Photograph of Rabindranath Tagore
c. 1935

1947, A Turning Point

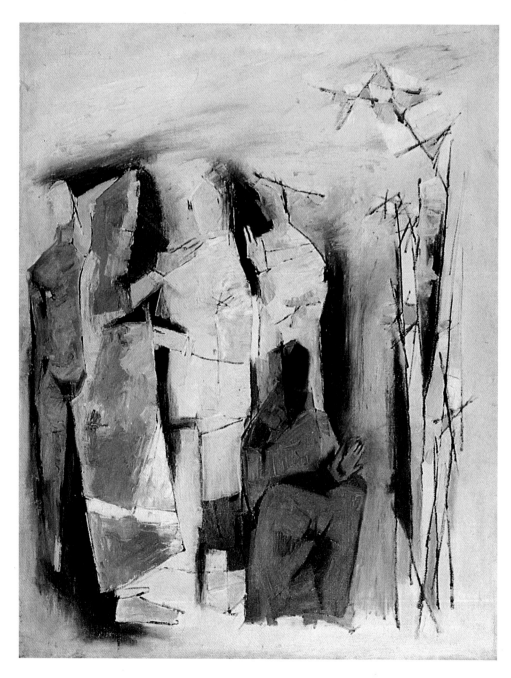

M. F. Husain, *Under the Tree*, 1959
Oil on canvas
96 × 76 cm (37¾ × 29⅞")

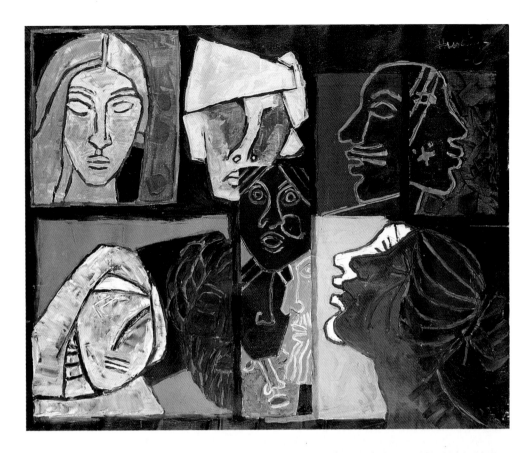

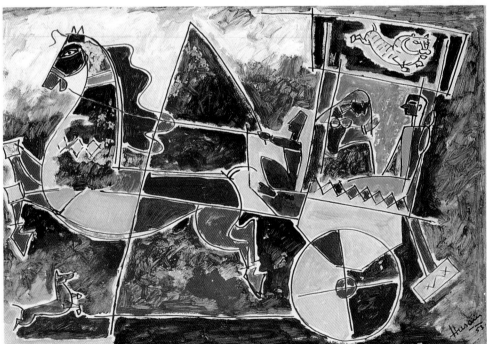

M. F. Husain, *Faces*, 1968
Acrylic on canvas
108 × 128 cm (42⅜ × 50¼")

M. F. Husain, *Bridal Tonga*, 1953
Gouache on paper
27 × 40 cm (10⅝ × 15¾")

61

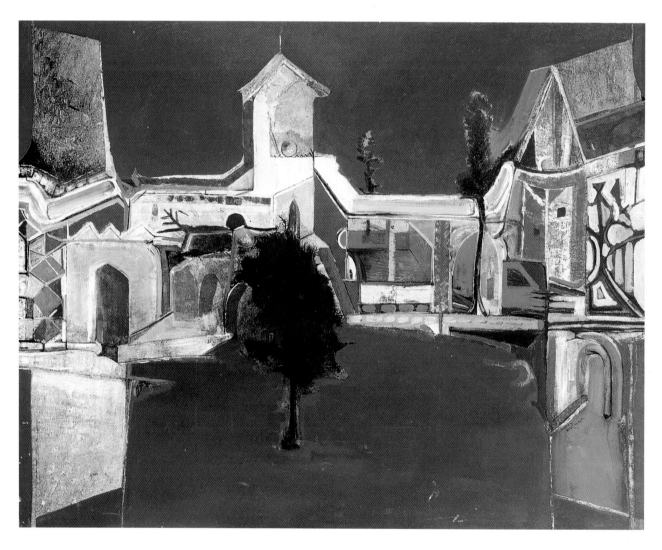

S. K. Bakre, *Untitled*, 1960
Oil on canvas
101 × 127 cm (39⅝ × 50")

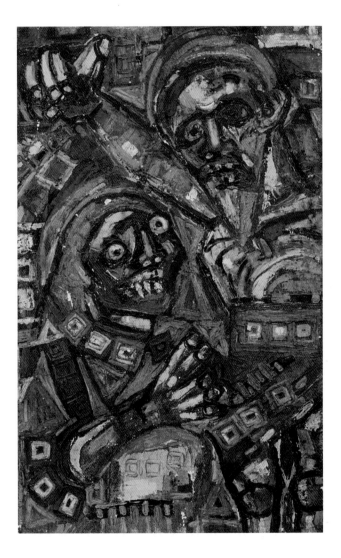

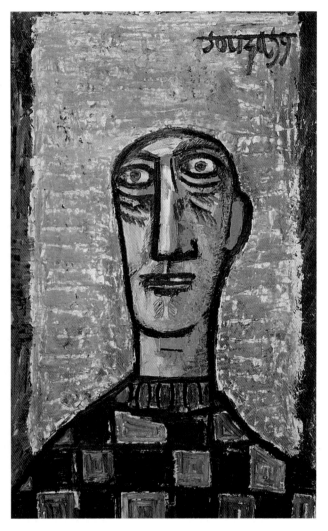

F. N. Souza, *Pieta*, 1947
Oil on canvas
91.5 × 60 cm (36 × 23½")

F. N. Souza, *Man with Check Shirt*, 1959
Oil on board
110 × 75 cm (43¼ × 29½")

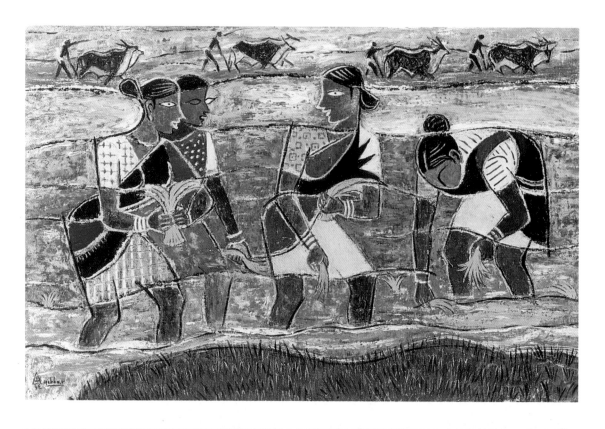

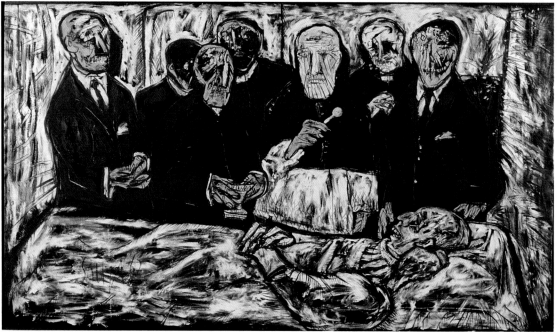

K. K. Hebbar, *Untitled*, 1950
Oil on canvas
58 × 87 cm (22¾ × 34⅛")

F. N. Souza, *Untitled*, 1962
Oil on canvas
118 × 203 cm (46¼ × 79¾")

64

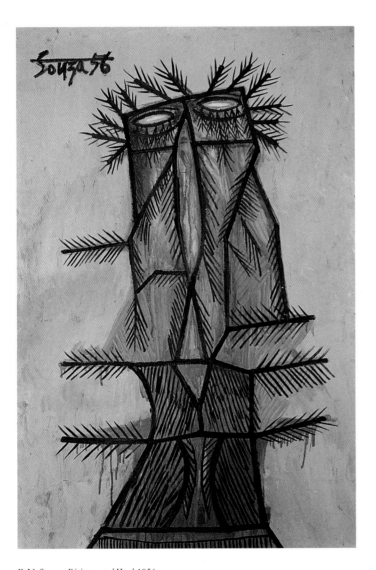

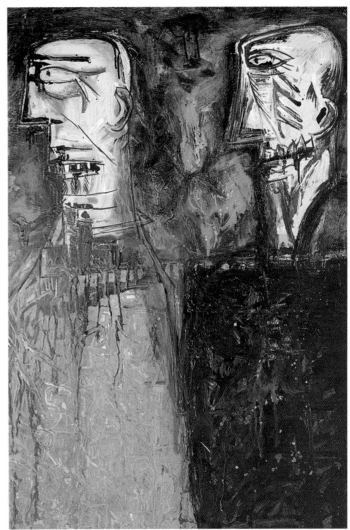

F. N. Souza, *Disintegrated Head*, 1956
Oil on board
120 × 80 cm (47 × 31½")

F. N. Souza, *The Politicians*, 1959
Oil on board
120 × 80 cm (47 × 31½")

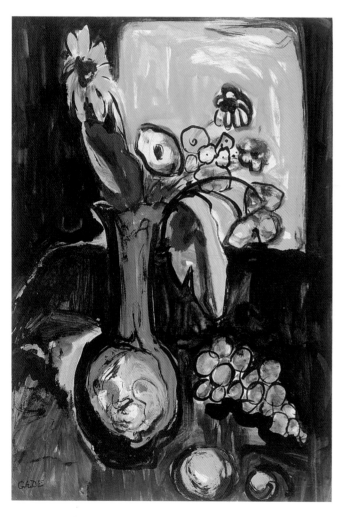

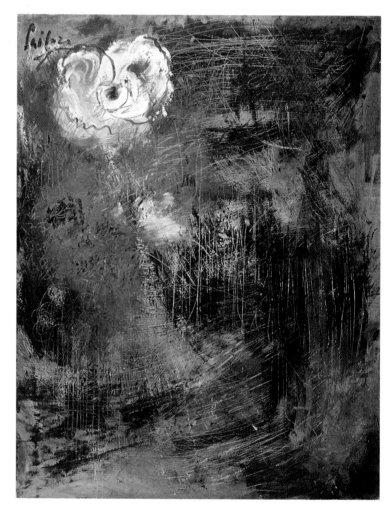

H. A. Gade, *Still Life with Vase of Flowers, c.* 1956
Gouache on paper
35.5 × 24 cm (14 × 9⅜")

Sailoz Mukherjee, *Untitled*, n.d.
Oil on canvas
80 × 70 cm (31½ × 27½")

Shifts of Emphasis

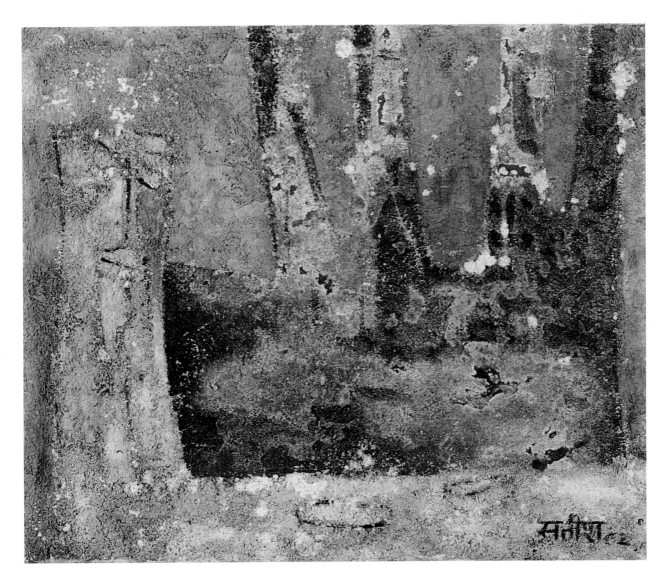

Satish Gujral, *Untitled*, 1962
Oil and plaster on canvas
70 × 84 cm (27½ × 33")

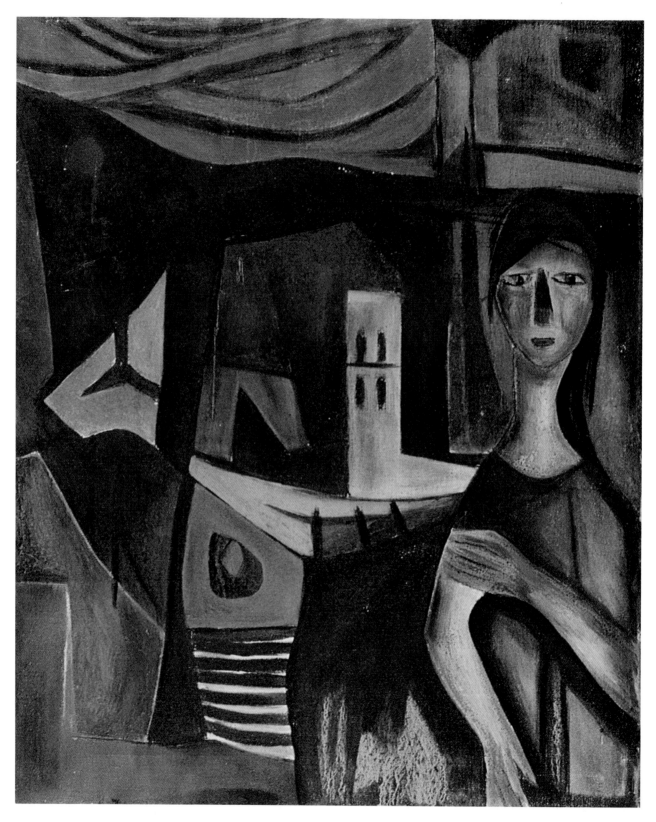

Ram Kumar, *Dream*, n.d.
Oil on canvas
65 × 53.5 cm (25½ × 21")

V. S. Gaitonde, *Untitled*, 1974
Oil on canvas
101.5 × 140 cm (39⅞ × 55")

V. S. Gaitonde, *Untitled*, 1972
Oil on canvas
101.5 × 178 cm (39⅞ × 70")

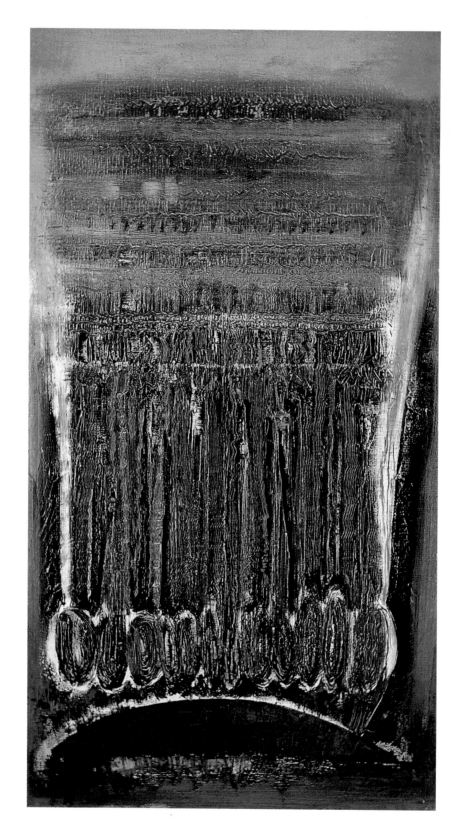

Laxman Pai, *Raag Bhairav*, 1965
Oil on canvas
127 × 65 cm (50 × 25½")

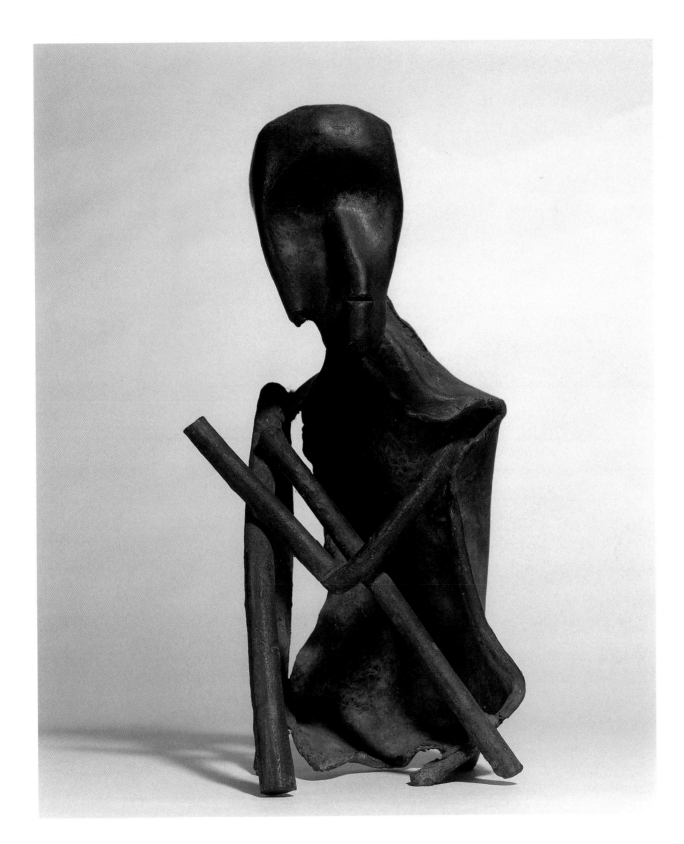

Somnath Hore, *Anger*, 1991
Bronze

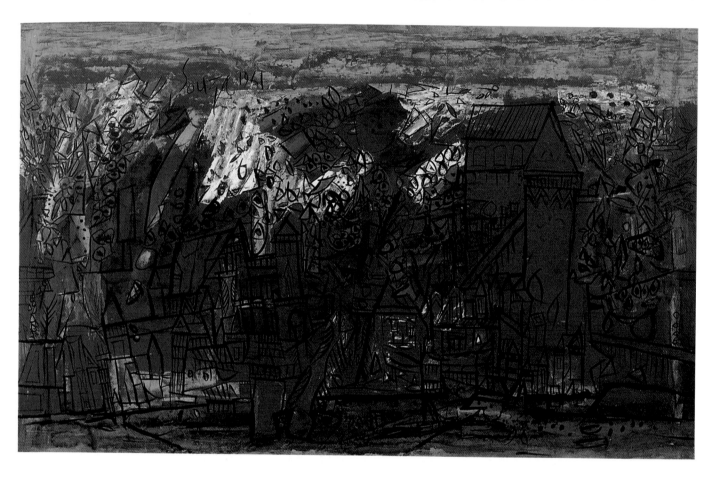

F. N. Souza, *Landscape*, 1961
Oil on canvas
77.5 × 127 cm (30½ × 50")

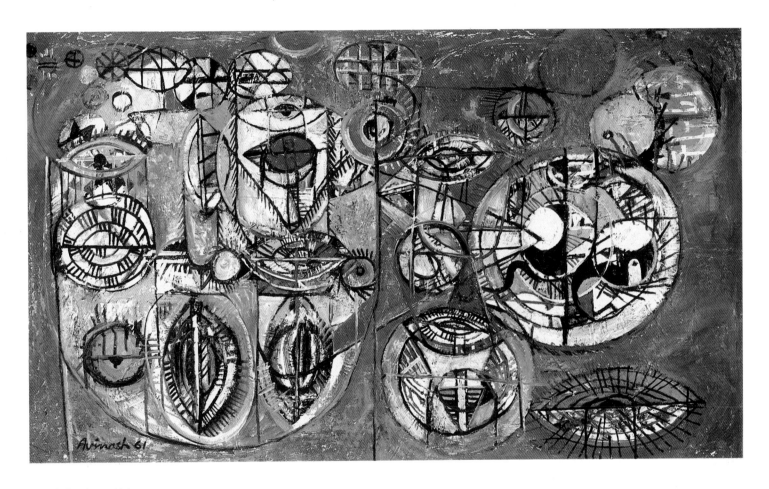

Avinash Chandra, *Untitled*, 1961
Oil on board
89.5 × 150 cm (35⅛ × 59")

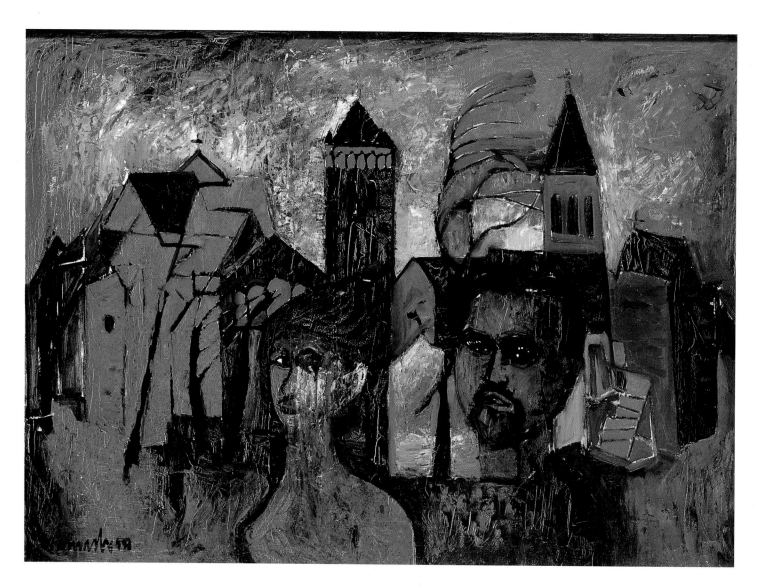

Avinash Chandra, *Churches*, 1978
Oil on board
73 × 98 cm (28⅝ × 38½")

Individualism

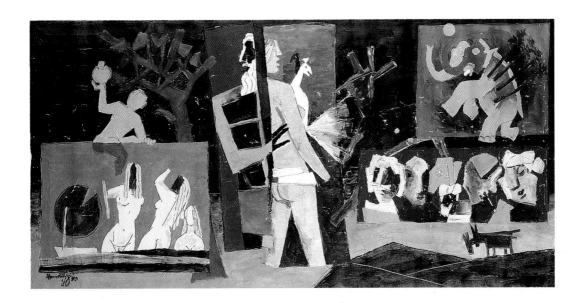

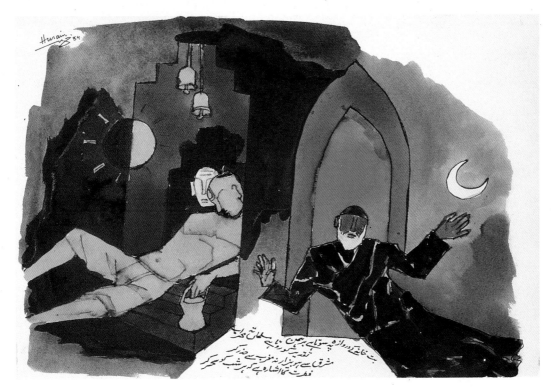

M. F. Husain, *Dreams*, 1979
Acrylic on canvas
110 × 220 cm (43¼ × 86½")

M. F. Husain, *Urdu Poetry Series*, 1984
Watercolour on paper
35.5 × 52 cm (14 × 20½")

بت خانے کے دروازے پہ سوتا ہے برہمن
تقدیر کو روتا ہے مسلماں تہ محراب

مشرق سے ہو بیزار' نہ مغرب سے حذر کر
فطرت کا اشارہ ہے کہ ہر شب کو سحر کر

Left: the poem in *Urdu Poetry Series*

At temple's door sleeps the Brahman,
Beneath the arch his fate the Mussalman
Laments. Spurn not the West, nor the East slight!
Nature's sign is: Turn darkness into light!

Allama Iqbal (translated by Iqbal Khan)

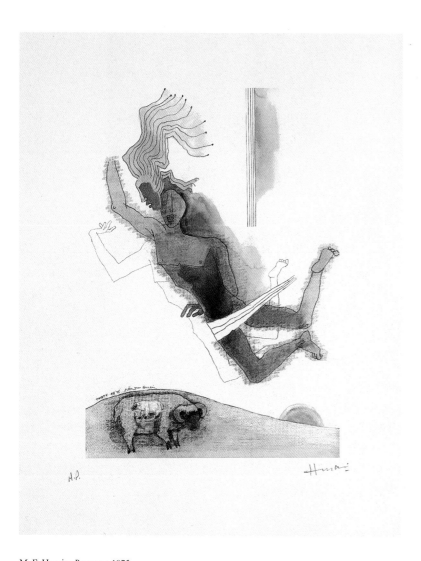

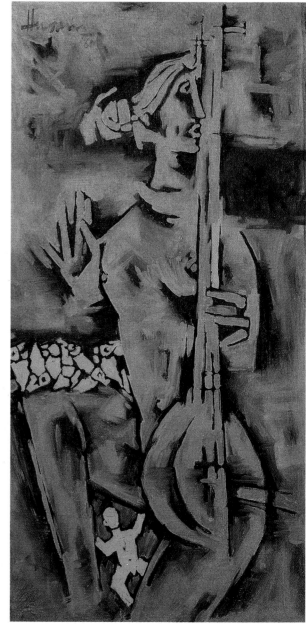

M. F. Husain, *Passage, c.* 1975
Watercolour on paper
40.5 × 30.5 cm (16 × 12")

M. F. Husain, *Sitar Player*, 1960
Oil on canvas
116 × 56 cm (45½ × 22")

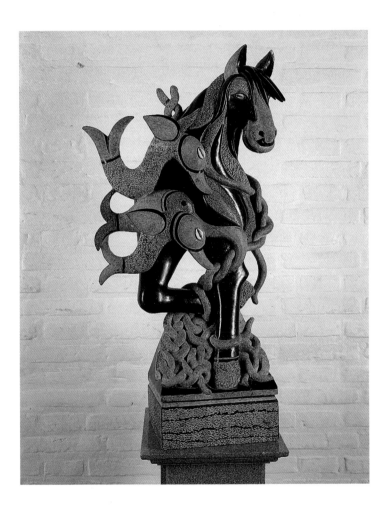

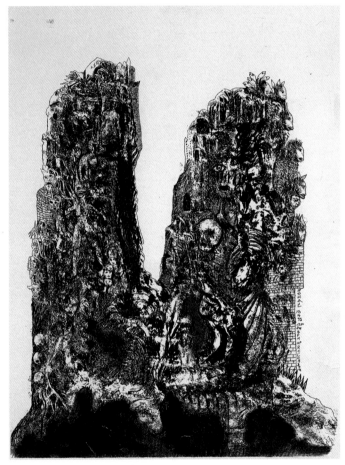

Satish Gujral, *Untitled*, 1995
Burnt wood and black granite
height 86 cm (33¼")

Tassadaq Sohail, *Pillars of Darkness*, 1991
Ink on paper
51 × 40.5 cm (20 × 16")

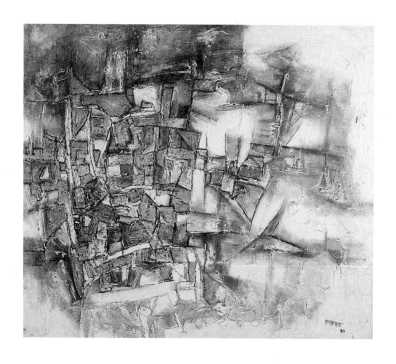

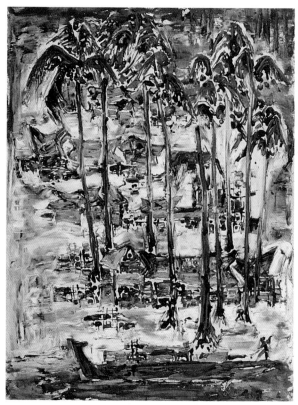

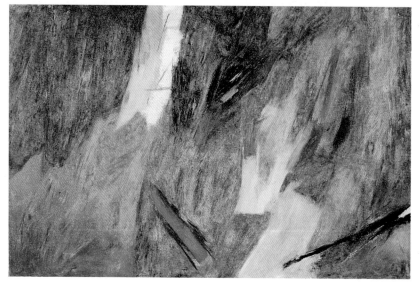

Ram Kumar, *Untitled*, 1972
Oil on canvas
84 × 152.5 cm (33 × 60")

Ram Kumar, *Untitled*, 1972
Oil on canvas

Ram Kumar, *Untitled*, 1973
Oil on canvas
84.5 × 127 cm (33¼ × 50")

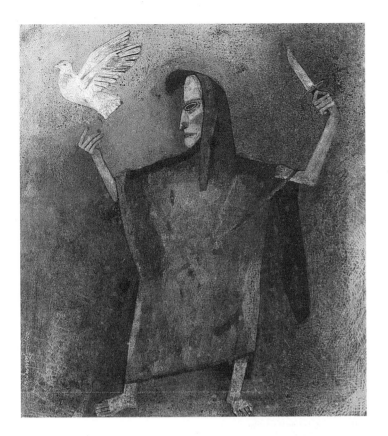

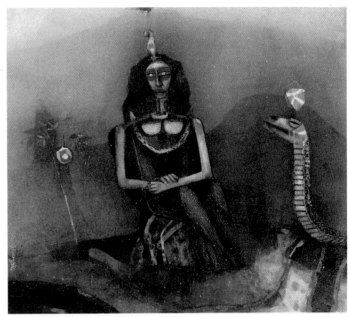

Ganesh Pyne, *The Dancer*, 1993
Tempera on canvas
39 × 34 cm (15¼ × 13½")

Ganesh Pyne, *Woman, the Serpent*, 1975
Tempera on canvas
19 × 22 cm (7½ × 8⅝")

Ganesh Pyne, *Fall*, 1971
Tempera on canvas
51 × 58 cm (20 × 22¾")

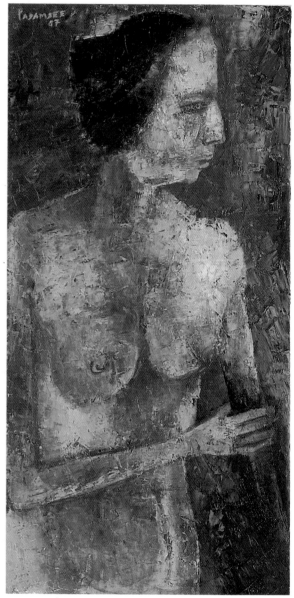

Akbar Padamsee, *Red Landscape*, 1977
Oil on canvas
180 × 123 cm (70¾ × 48¼")

Akbar Padamsee, *Nude*, 1987
Oil on canvas
122 × 61 cm (48 × 24")

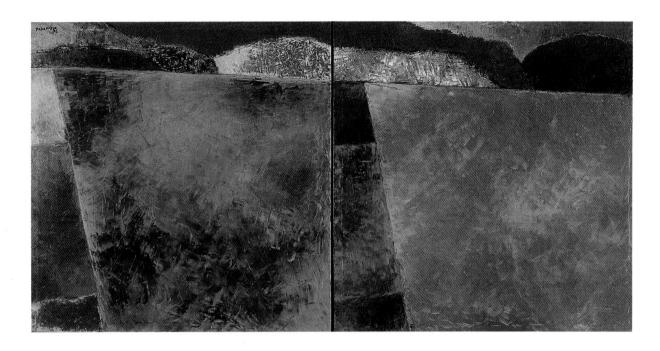

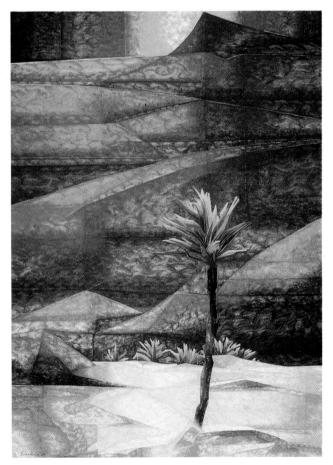

Akbar Padamsee, *Mirror Image, Diptych II*, 1994
Oil on canvas
109 × 218.5 cm (43 × 86")

Jahangir Sabavala, *The Palm Tree*, 1989
Oil on canvas
125 × 90 cm (49 × 35½")

New Horizons

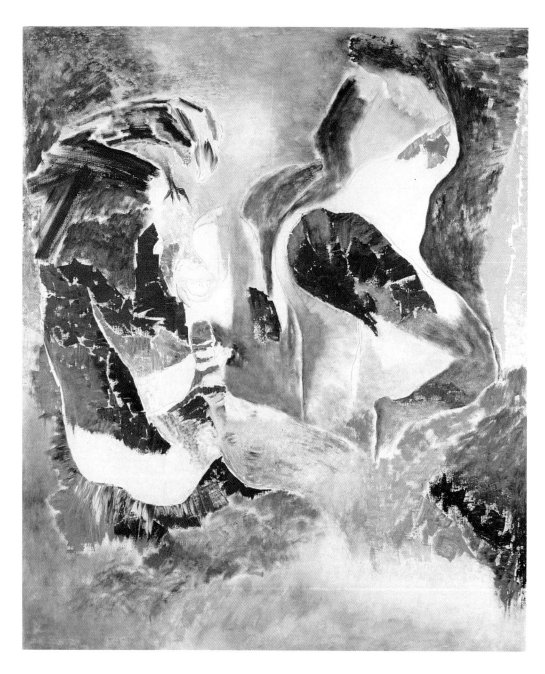

Bal Chhabda, *Beauty and the Beast*, 1984
Oil on canvas
183 × 152 cm (71⅞ × 59¾")

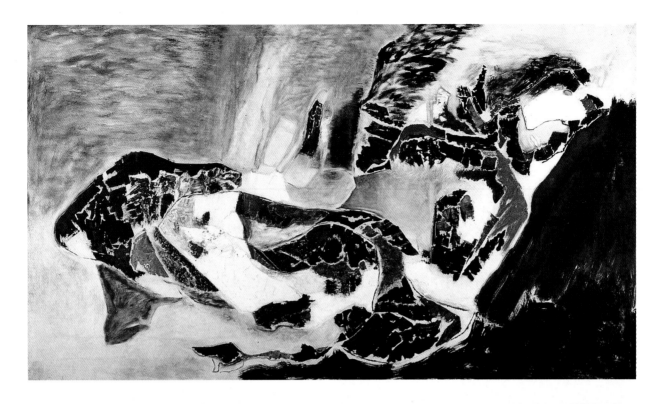

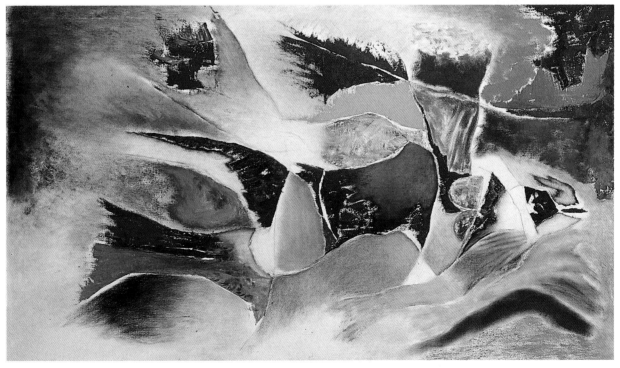

Bal Chhabda, *Frailty, Thy Name is Woman*, 1968
Oil on canvas
132 × 233.6 cm (51¼ × 91¾")

Bal Chhabda, *Facets of Eve*, 1991
Oil on canvas
170 × 99 cm (66¾ × 39")

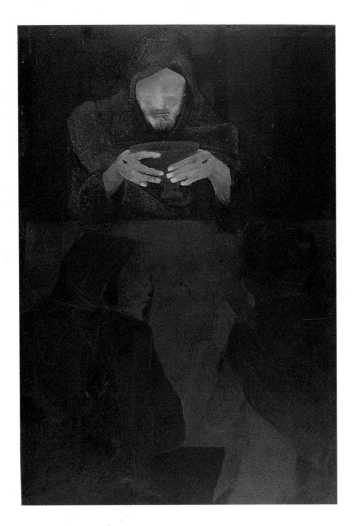

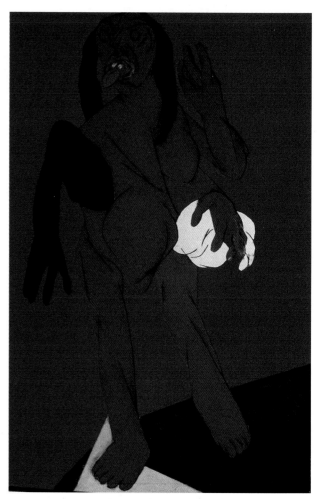

Krishen Khanna, *Untitled*, 1973
Oil on canvas
167.5 × 119 cm (65¼ × 46¼")

Tyeb Mehta, *Kali III*, 1989
Acrylic on canvas
150 × 96 cm (59 × 37¾")

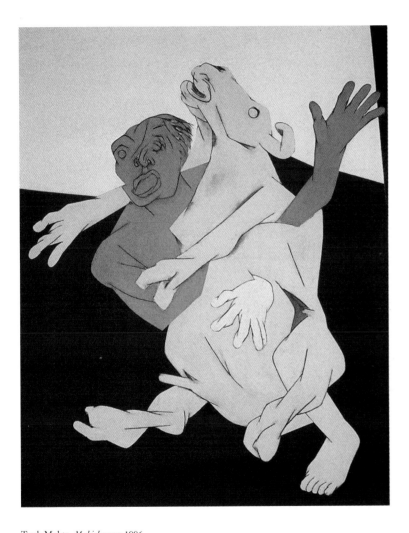

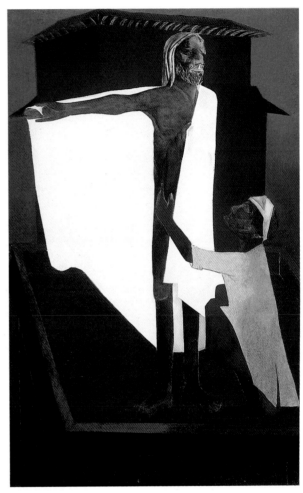

Tyeb Mehta, *Mahishasura*, 1996
Acrylic on canvas
122 × 92 cm (48 × 36⅛")

Krishen Khanna, *Reach Hither Thy Hand and Thrust It into My Side*, 1980
Acrylic on canvas
176 × 112 cm (69⅛ × 44")

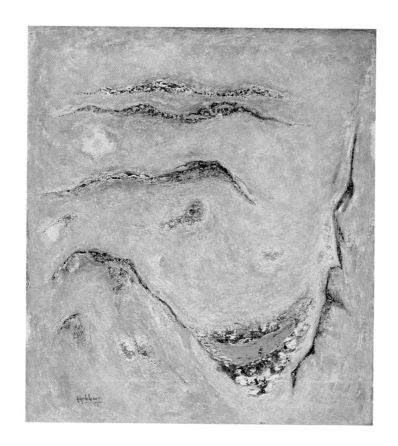

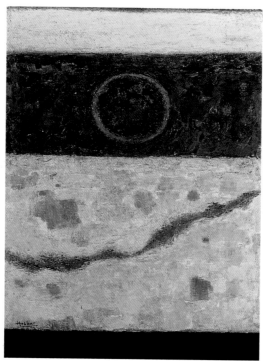

K. K. Hebbar, *Untitled*, 1972
Oil on canvas
96.5 × 106.5 cm (38 × 41¼")

K. K. Hebbar, *The Pathway*, 1972
Oil on canvas
114 × 86 cm (44¼ × 33¼")

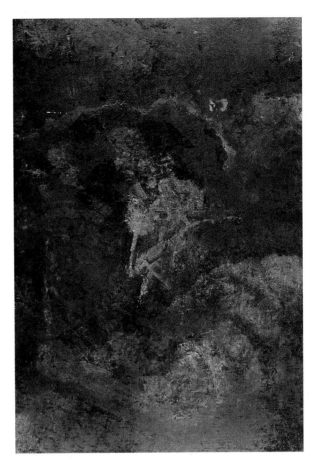

V. S. Gaitonde, *Untitled*, 1985
Oil on canvas

Mohan Samant, *Untitled*, 1967
Oil on canvas
169 × 142 cm (67 × 56")

V. S. Gaitonde, *Untitled*, 1952
Watercolour on paper
37 × 43 cm (14½ × 16¾")

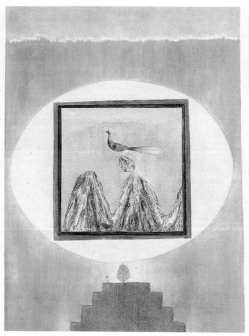

J. Swaminathan, *Kalateet*, 1978
Oil on canvas
82 × 116 cm (32¼ × 45½")

J. Swaminathan, *Untitled*, 1974
Oil on canvas
124 × 124 cm (48¾ × 48¾")

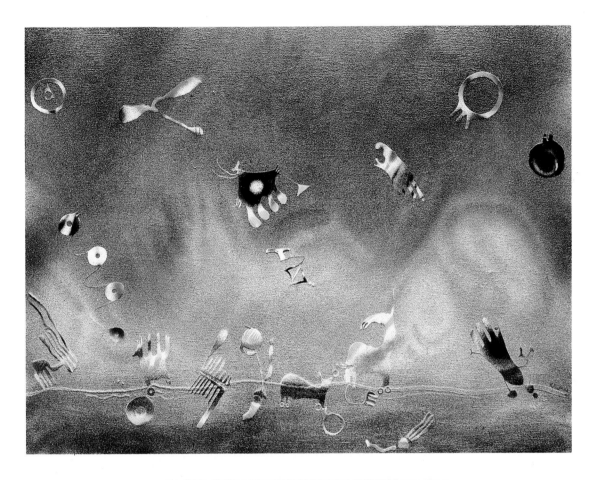

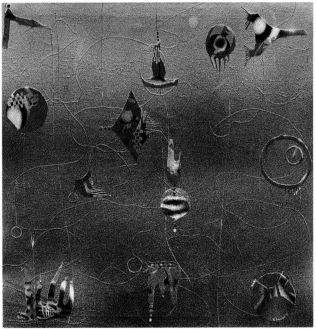

Balraj Khanna, *Monsoon*, 1996
Acrylic and sand on canvas
112 × 146 cm (44 × 57¼")

Balraj Khanna, *Apple Green*, 1991
Acrylic on canvas
110 × 110 cm (43¼ × 43¼")

89

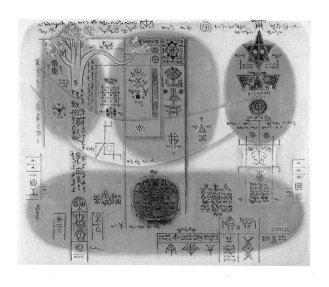

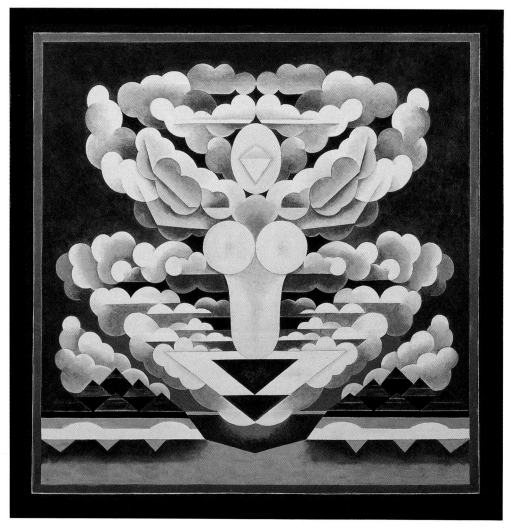

K. C. S. Paniker, *Words and Symbols*, 1970
Oil on canvas

G. R. Santosh, *Untitled*, 1990
Acrylic on canvas
152 × 152 cm (59¾ × 59¾")

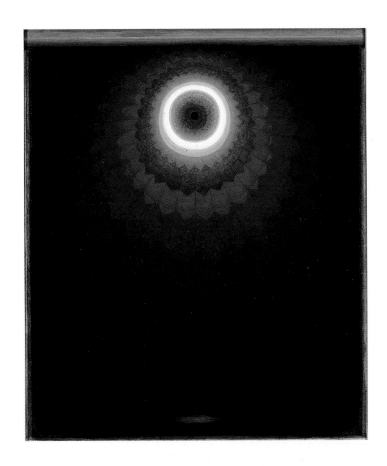

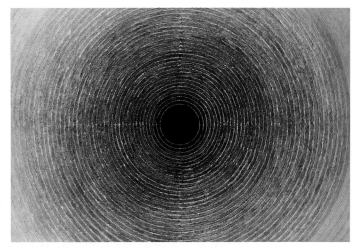

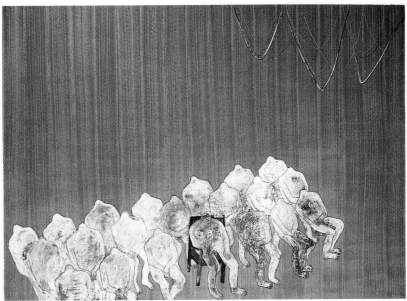

Biren De, *January*, 1992
Oil on canvas
111 × 96 cm (43⅝ × 37¾")

S. H. Raza, *Nad Bindu*, 1994 (detail)
Acrylic on canvas
150 × 150 cm (59 × 59")

Rameshwar Broota, *Reconstruction*, 1977
Oil on canvas
127 × 178 cm (50 × 70")

V. Viswanadhan, *Untitled*, 1993
Caesin on canvas
203 × 203 cm (79¾ × 79¾")

Magic in Realism

K. G. Subramanyan, *Visions of a Yellow Moon*, 1994
Oil on canvas
140 × 140 cm (55 × 55")

K. G. Subramanyan, *Ethiopian Nativity*, 1988
Reverse painting on acrylic sheet
81 × 61 cm (31¾ × 24")

K. G. Subramanyan, *Fire Extinguisher*, 1990
Gouache on paper
105 × 80 cm (41¼ × 31½")

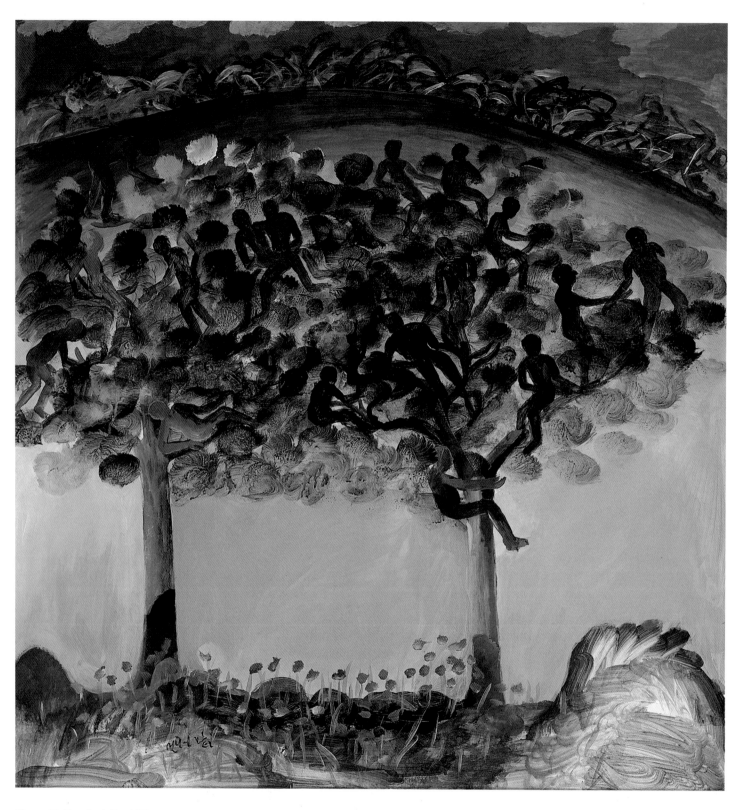

Bhupen Khakhar, *On the Tree*, 1991
Acrylic on paper
96 × 101 cm (37¾ × 39¾")

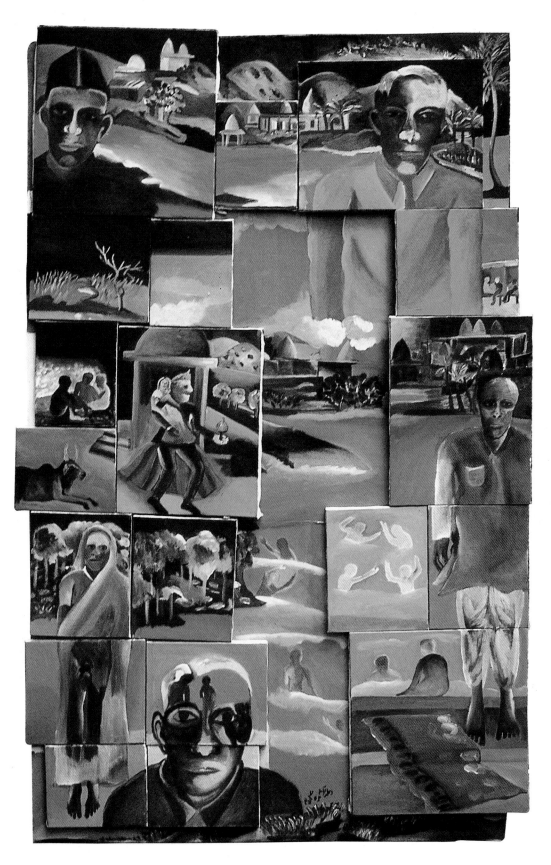

Bhupen Khakhar, *Night Out*, 1996
Oil on canvas
207 × 129 cm (81¼ × 50⅝")

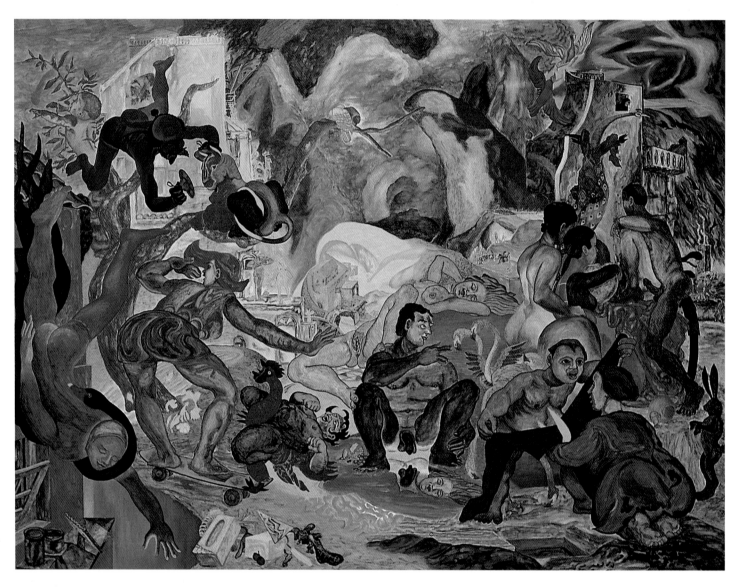

Ranbir Kaleka, *The Story Teller*, 1995
Oil on linen
183 × 244 cm (72 × 95⅞")

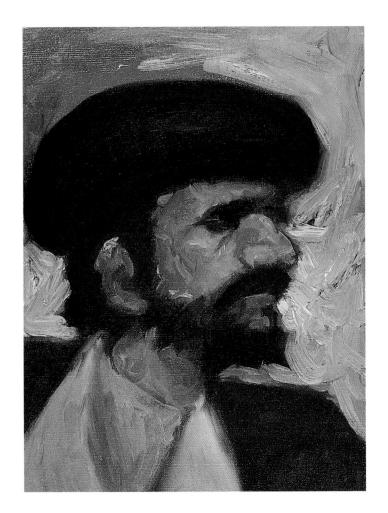

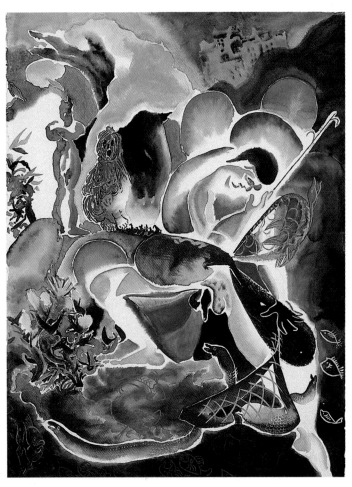

Sudhir Patwardhan, *Head I*, 1986
Oil on canvas
30 × 22 cm (11¾ × 8¾")

Ranbir Kaleka, *Fisher*, 1992
Watercolour on paper
76 × 58 cm (29¾ × 22¾")

Gieve Patel, *Battered Body in Landscape*, 1993
Oil on canvas
70 × 85 cm (27½ × 33⅜")

Gieve Patel, *The Watertank at Nargol*, 1993
Acrylic on canvas
170 × 190.5 cm (67 × 75")

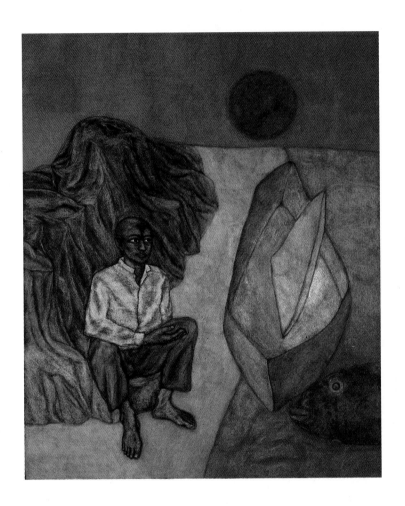

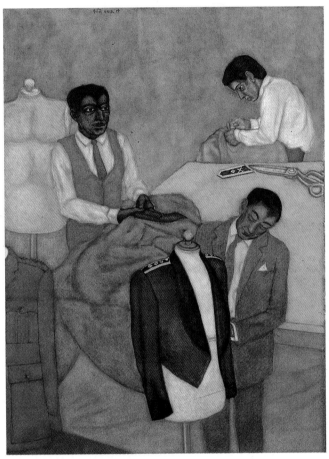

Shanti Panchal, *The Paper Boat*, 1994
Watercolour on paper
180 × 147 cm (70¾ × 57¾")

Shanti Panchal, *The Cotton, the Scissors and the Uniform*, 1988
Watercolour on paper
173 × 132 cm (68 × 51¾")

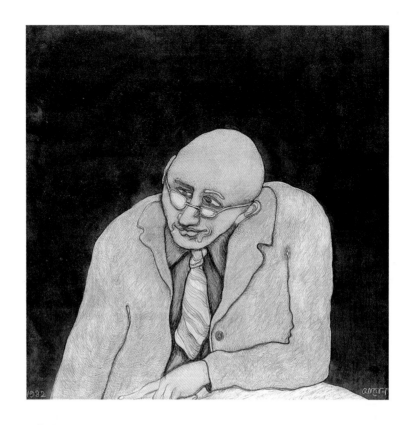

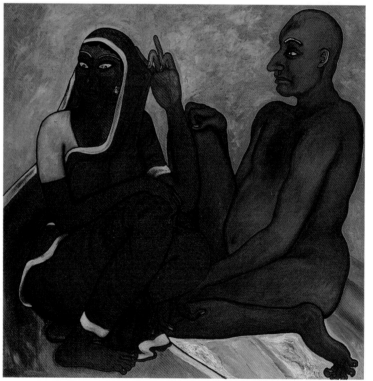

Jogen Chowdhury, *Man in Pink Coat*, 1982
Mixed media on paper
51 × 51 cm (20 × 20")

Jogen Chowdhury, *Couple*, 1995
Oil on canvas
120 × 120 cm (47⅛ × 47⅛")

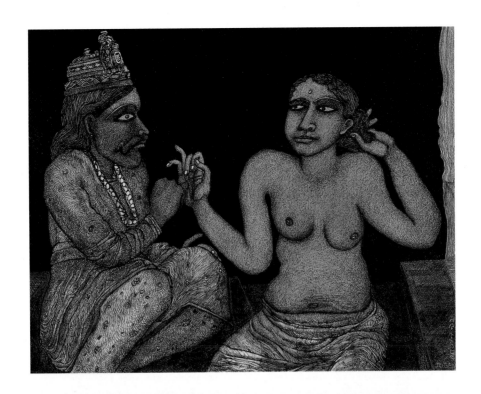

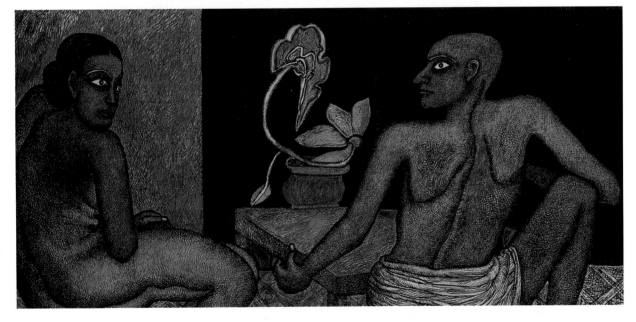

Jogen Chowdhury, *The Invisible King*, 1992
Ink and pastel on paper
55 × 70 cm (21⅝ × 27½")

Jogen Chowdhury, *The Flower*, 1990
Ink and pastel on paper

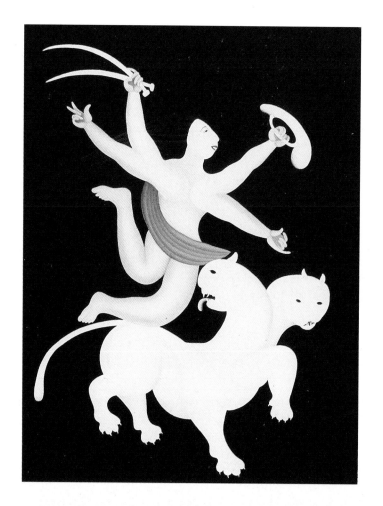

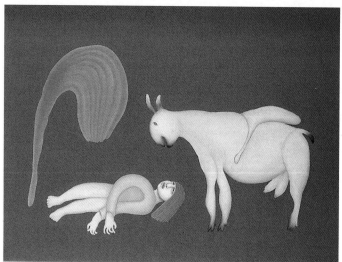

Manjit Bawa, *Goddess on a Tiger*, 1996
Oil on canvas
244 × 183 cm (95¾ × 71⅞")

Manjit Bawa, *A Goat, a Girl and a Tree*, 1982
Oil on canvas
137 × 163 cm (53¾ × 64")

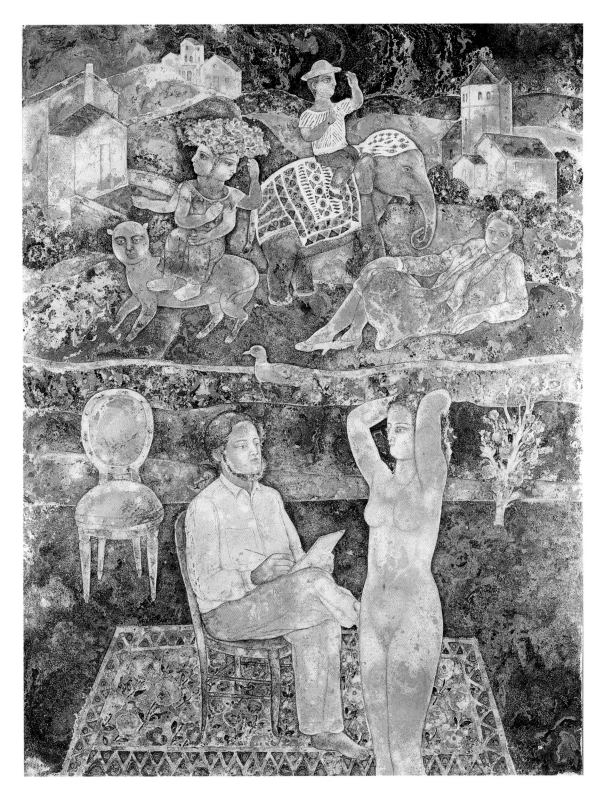

Sakti Burman, *Artist and his Model*, 1994
Oil on canvas
116 × 89 cm (45½ × 35")

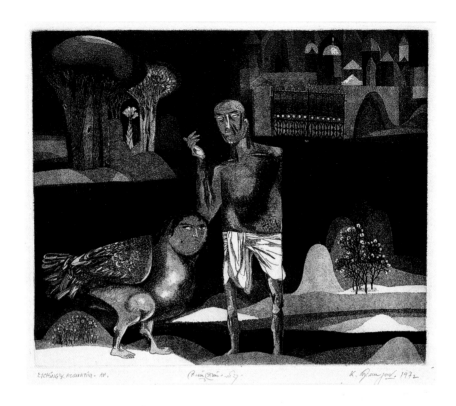

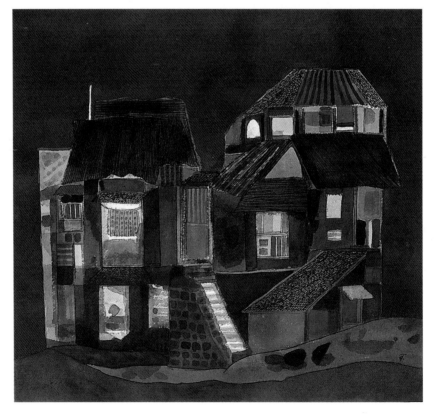

Laxma Goud, *Untitled*, 1972
Aquatint
26 × 31 cm (10 × 12")

Badri Narayan, *Old Houses*, 1995
Watercolour on paper
48 × 51.5 cm (18¾ × 20¼")

A New Phenomenon
and Young India

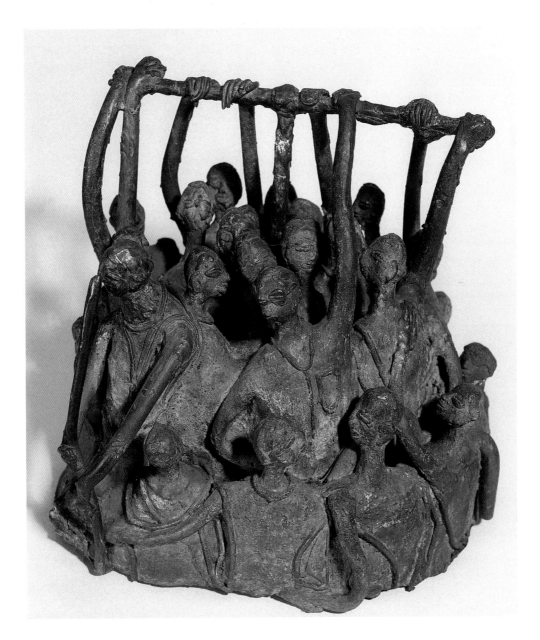

Meera Mukherjee, *Minibus*, 1989
Bronze

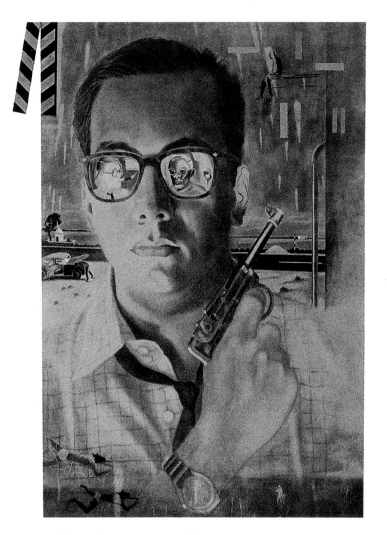

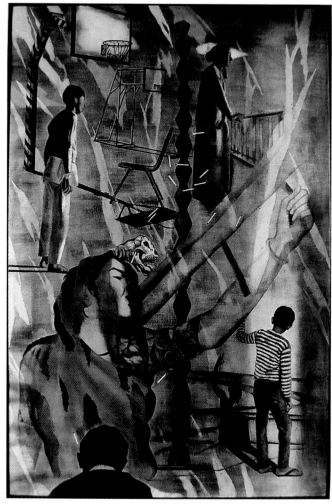

Atul Dodiya, *The Bombay Buccaneer*, 1994
Oil, acrylic and wood on canvas
183 × 122 cm (72 × 48")

Atul Dodiya, *Heroic Fiddling*, 1996
Oil and acrylic on canvas
183 × 122 cm (72 × 48")

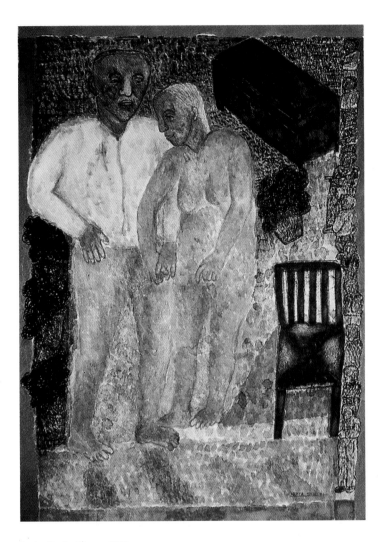

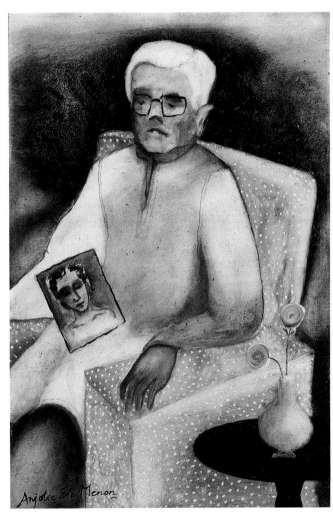

Arpita Singh, *Afternoon*, 1994
Watercolour on paper
50 × 35 cm (19¾ × 13¾")

Anjolie Ela Menon, *Portrait*, 1989
Oil on canvas
91 × 61 cm (35¼ × 24")

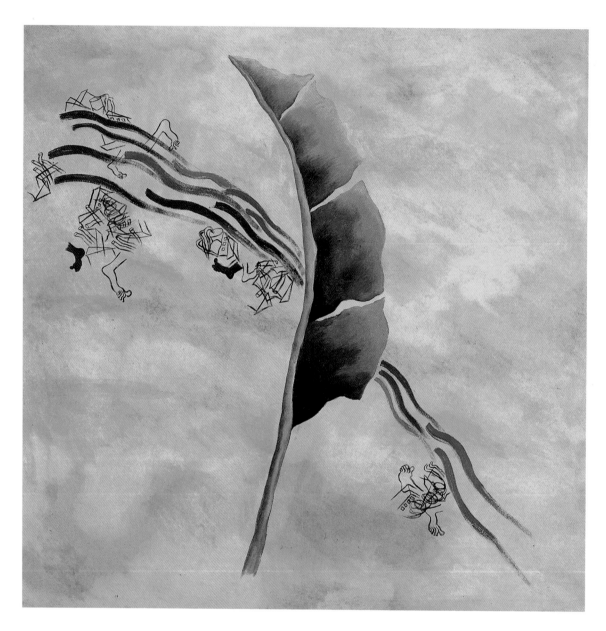

Arpana Caur, *Resilient Omen*, 1991
Oil on canvas
173 × 173 cm (68 × 68")

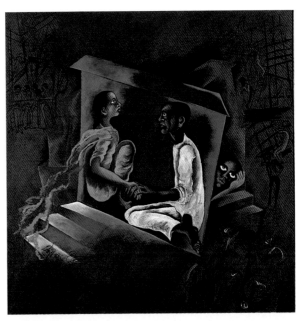

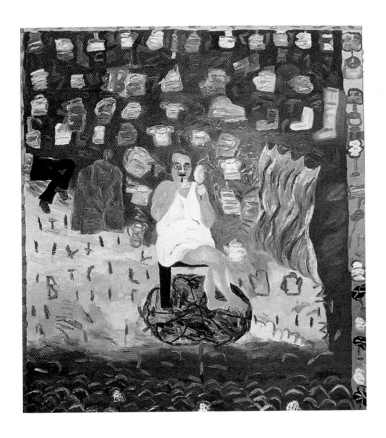

Arpita Singh, *A Woman Putting on Lipstick*, 1995
Oil on canvas
165 × 150 cm (64¾ × 59")

Arpana Caur, *Triptych*, n.d.

Arpita Singh, *A Woman, a Man*, 1994
Watercolour on paper
50 × 35 cm (19 × 14")

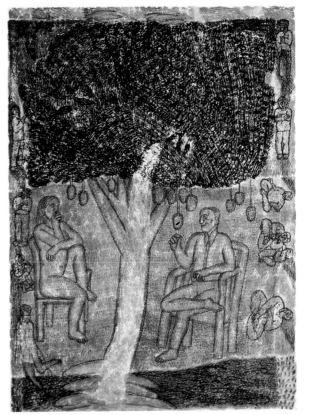

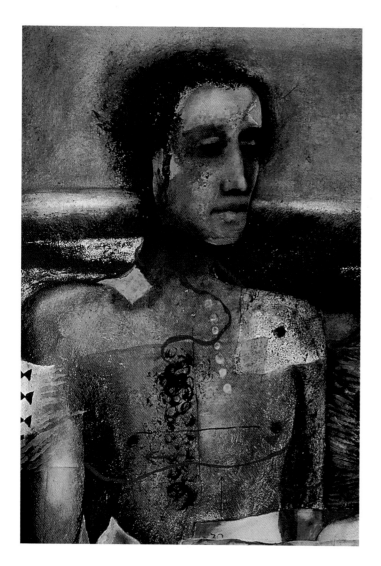

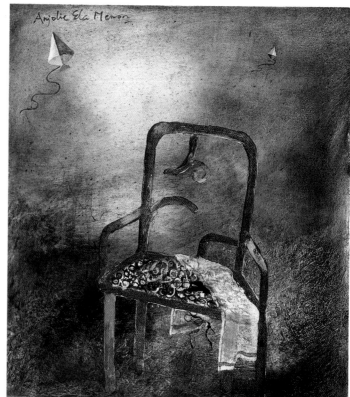

Anjolie Ela Menon, *The Fisherman's Tale*, 1995 (detail)
Oil on masonite

Anjolie Ela Menon, *Malabar*, n.d.
Oil on masonite

Nasreen Mohamedi, *Untitled*, 1976
Pencil and ink on paper

Nasreen Mohamedi, *Untitled*, c. 1976
Pencil and ink on paper
28 × 33 cm (11 × 13")

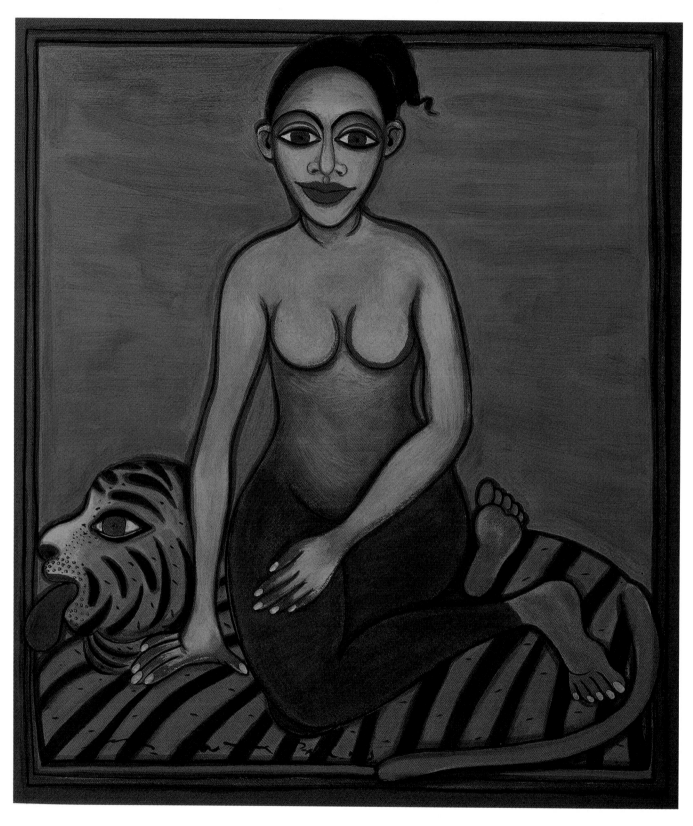

Gogi Saroj Pal, *Hatyogini Naika*, 1996
Gouache on paper
60 × 50 cm (23½ × 19¼")

K. Achutan, *Untitled*, 1990
Oil on canvas
119 × 111 cm (46¾ × 43⅝")

K. Achutan, *Brown and Red*, 1995
Oil on canvas
180 × 180 cm (70¾ × 70¾")

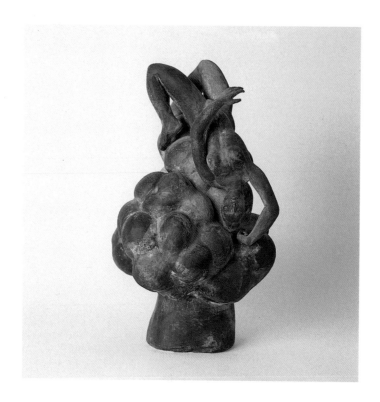

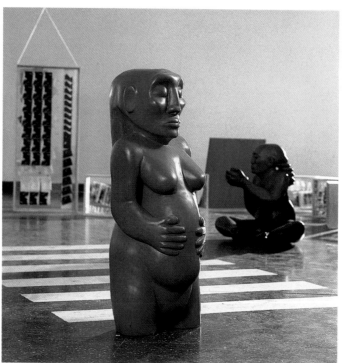

Trupti Patel, *The Fall II*, 1989
Fired clay
50 × 38 × 31 cm (19⅝ × 15 × 12⅛")

Navjot Altaf, *Across the Crossing*, 1994
Painted wood
110 × 43 × 45 cm (43 × 17 × 18")

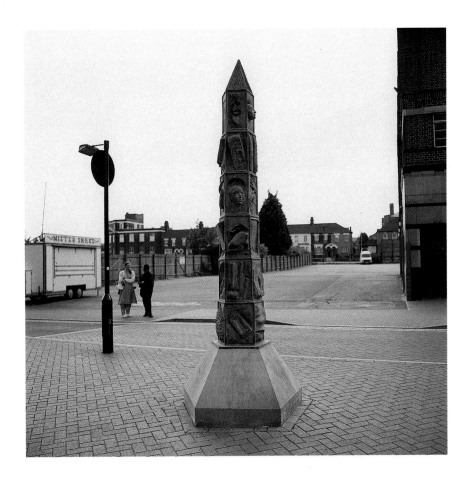

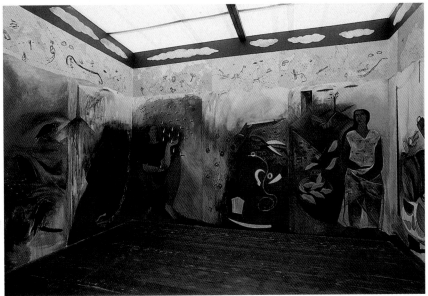

Trupti Patel, *Essentials*, 1995
Bronze
120 × 20 × 20 cm (47⅛ × 7¾ × 7¾")

Rekha Rodwittiya, *Songs from the Blood of the Weary*, 1995
Acrylic and oil on canvas and wood
4.2 × 4.2 × 3.5 m (13¾ × 13¾ × 11.5')

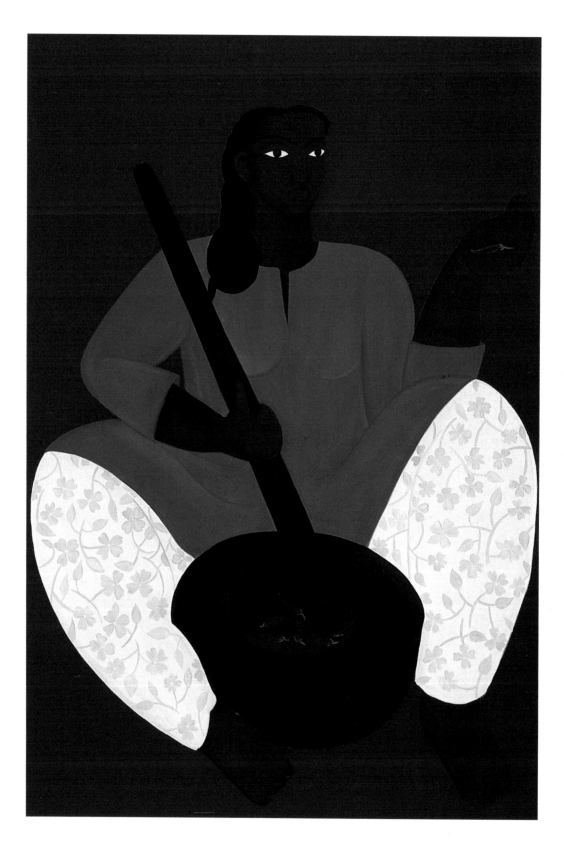

Rekha Rodwittiya, *The Chillie Pounder*, 1996
Acrylic on canvas
182 × 122 cm (71.5 × 48")

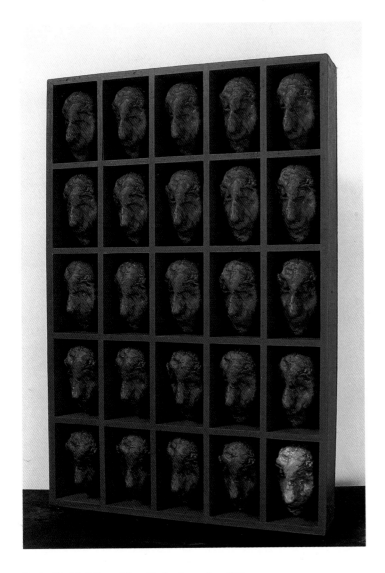

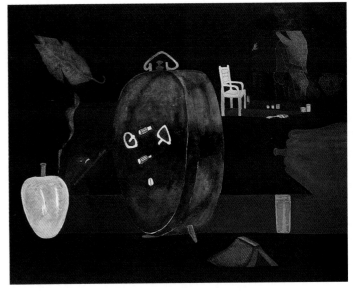

Navjot Altaf, *Red, Blue and Green, Bombay Cosmopolitan*, 1995
Mixed media

Prabhakar Barwe, *The Clock*, 1991
Oil on canvas
122 × 152 cm (48 × 59¾")

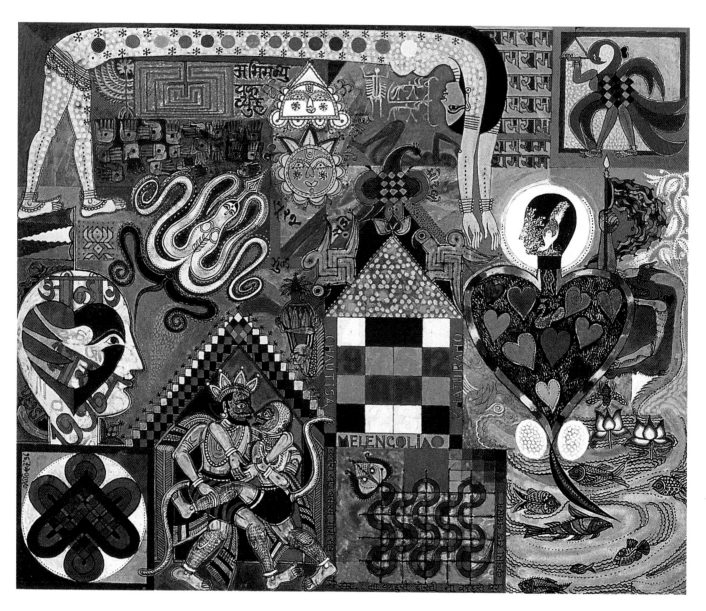

Jyoti Bhatt, *Nostalgic Images*, 1996
Acrylic on board
51 × 61 cm (20 × 24")

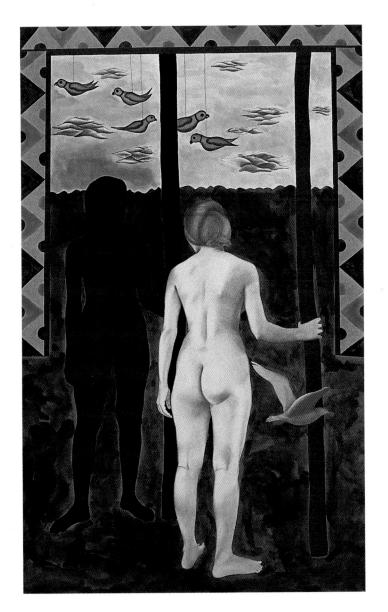

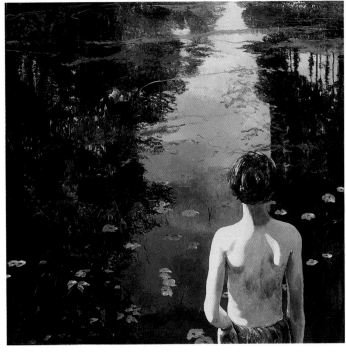

V. Tewari, *The Inner, the Outer*, n.d.
Acrylic and pencil on paper

Bikash Bhattacharjee, *Babul*, 1994
Acrylic on canvas
105 × 115 cm (41⅛ × 45⅛")

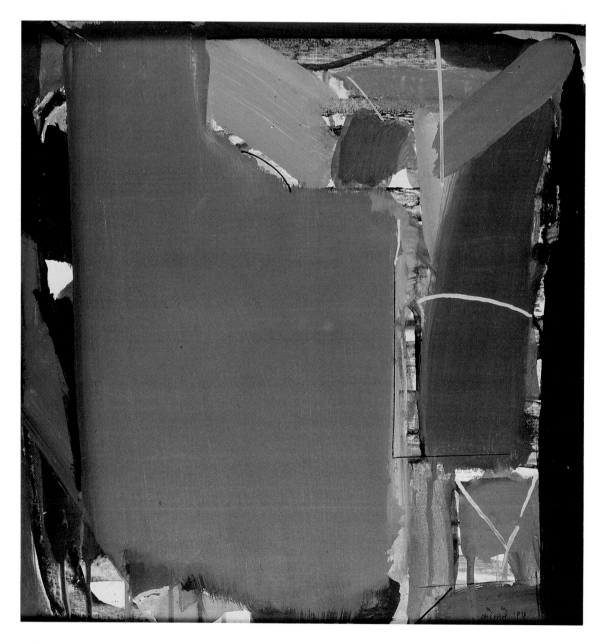

Prabhakar Kolte, *Untitled*, 1995
Watercolour on board
50.8 × 48.2 cm (20 × 19")

The Future of Contemporary Indian Art

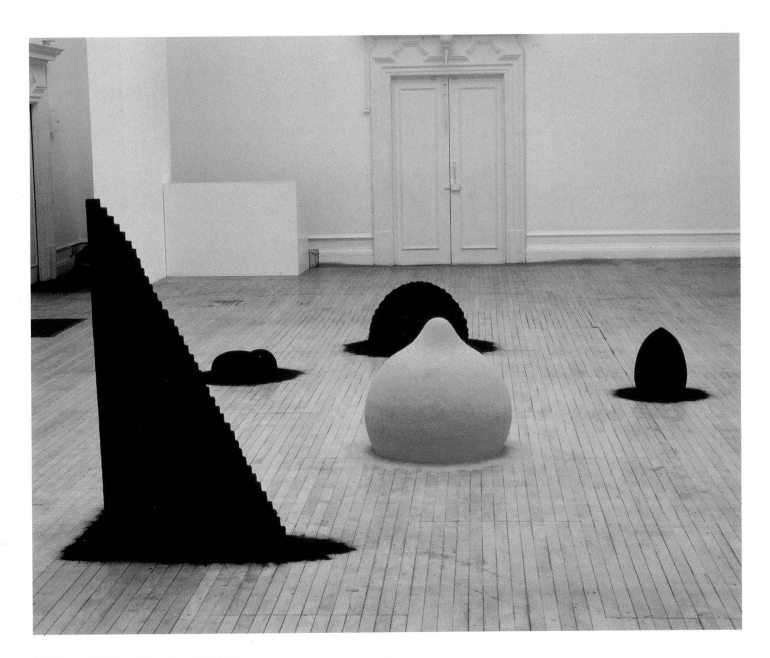

Anish Kapoor, *To Reflect an Intimate Part of the Red*, 1981
Pigment and mixed media
2 × 8 × 8 m (6½ × 26¼ × 26¼')

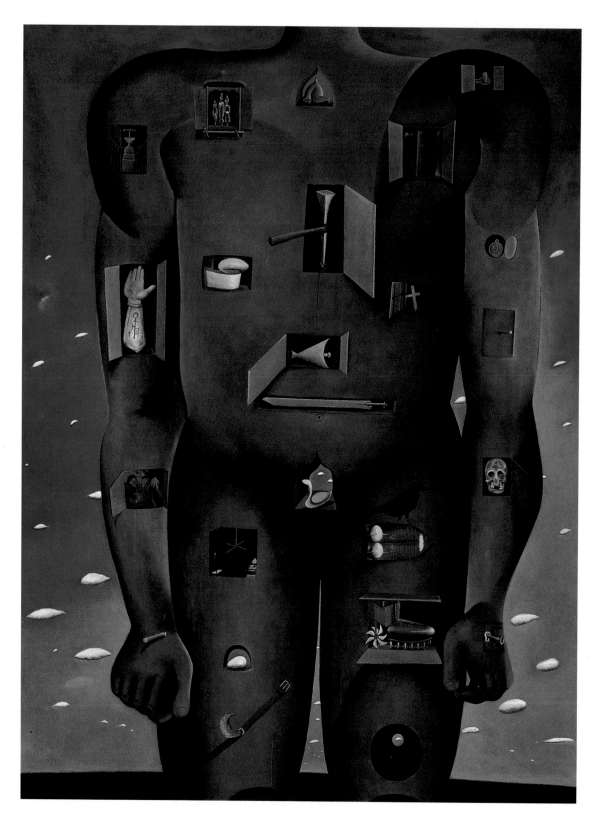

Surrendran Nair, *Auto Da Fe*, 1995–96
Acrylic and oil on canvas
241 × 178 cm (94¾ × 70")

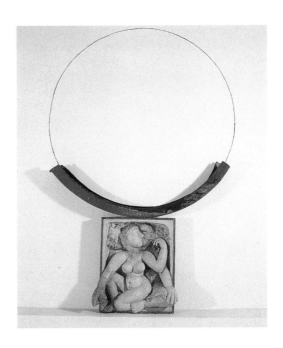

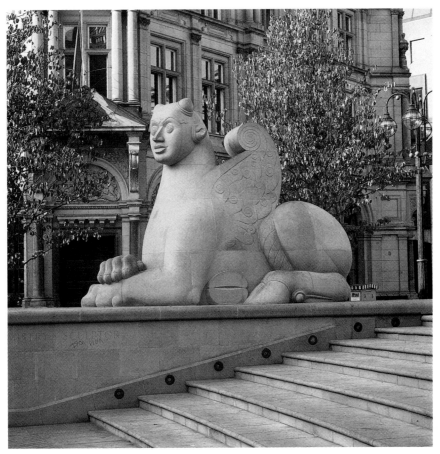

N. N. Rimzon, *Blue Moon in October*, 1989
Plaster, steel, wood and charcoal
276 × 80 × 33 cm (108½ × 31½ × 13")

Dhruva Mistry, *Victoria Square Guardians, Birmingham*, 1991–93
Bronze and Darleydale sandstone

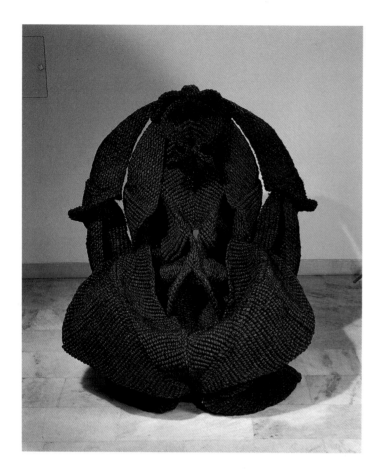 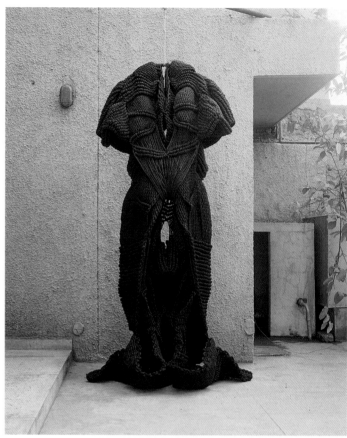

Mrinalini Mukherjee, *Aranyani*, 1996
Hemp
142 × 127 × 104 cm (55¼ × 50 × 40¼")

Mrinalini Mukherjee, *Yakshi*, 1984
Hemp
225 × 130 × 66 cm (88½ × 51 × 26")

Dhruva Mistry, *Unmasked*, 1995
Wood and enamel
Diameter 55.8 cm (22")

Dhruva Mistry, *Unmasked*, 1995
Wood and enamel
Diameter 76.2 cm (30")

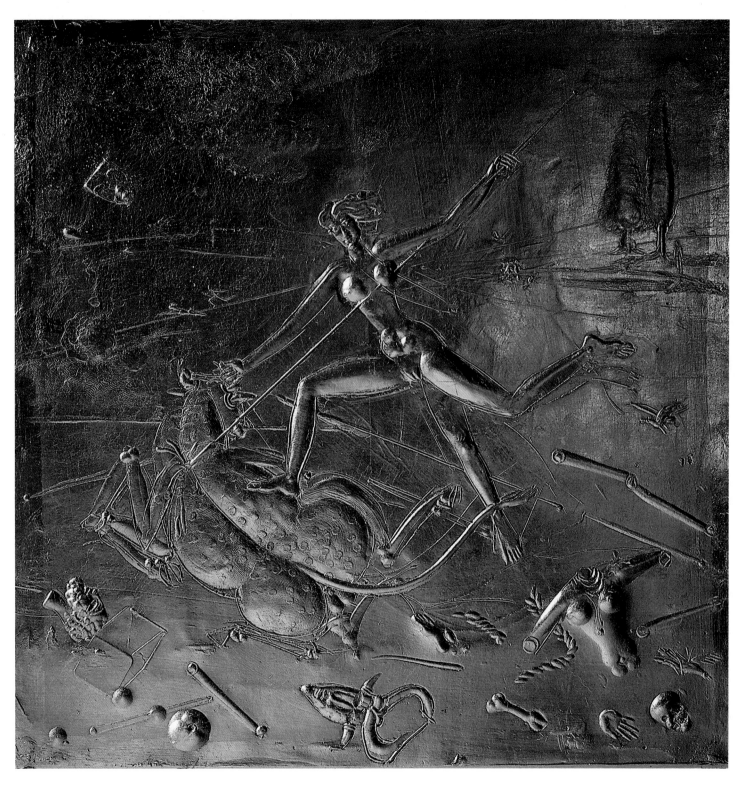

Dhruva Mistry, *Light, Passion and Darkness*, 1992–93
Plaster and goldleaf
30.5 × 30.5 cm (12 × 12")

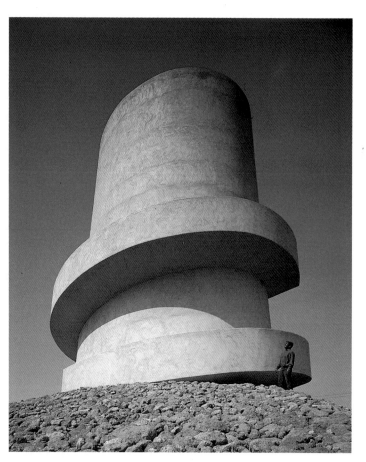

Anish Kapoor and David Connor, *Building for a Void*, 1992
Concrete and stucco
Height 15 m (49¼')

Ved Nayar, *Two Faces*, 1987
Bronze
Height 150 cm (59")

Biographies

Bibliography

Acknowledgments

Index

Biographies

K. H. Ara (1914–85)
Born in Bolarum near Secunderabad, Andhra Pradesh, he moved to Mumbai in 1921. He was later imprisoned for his involvement in the Salt Satyagraha. He had his first show in 1942 and was awarded the Governor's Prize in 1944. He was a founder member of the Progressive Artists' Group and exhibited with them. In 1952 he received a gold medal from the Bombay Art Society. He was on the selection and judging committee of the Lalit Kala Akademi, New Delhi.

Amitabha Banerjee (b. 1929)
Born in Barisal, Bangladesh, he studied at the Government College of Arts and Crafts, Calcutta. He has had several solo shows in India, America, Canada and Bangladesh. He received the AIFACS Award (1976), the Birla Academy of Art and Culture Award (1978) and the Lalit Kala National Award. His works are on display in the Lalit Kala Akademi, New Delhi, the National Gallery of Modern Art, New Delhi, and the Birla Academy of Art and Culture, Calcutta.

Manjit Bawa (b. 1941)
Born in the Punjab, he studied at the College of Art in New Delhi and at the London School of Printing. From 1967 to 1971 he worked as a silk-screen printer in London. After returning to India in 1972, he held solo shows in Mumbai and Delhi, and was represented in several international exhibitions, including *Contemporary Indian Art*, Royal Academy of Arts, London (1982), *Modern Indian Paintings*, Hirshhorn

Museum, Washington, D.C. (1982), *Contemporary Indian Art*, Grey Art Gallery, New York (1985) and *Coups de Coeur*, Halles de l'Ile, Geneva (1987). His work is part of the permanent collections of the National Gallery of Modern Art, New Delhi, and the Punjab University Museum of Chandigarh. He is noted for his love of animal forms and his characteristic use of space and colour. He received the National Award, and now lives and works in Delhi.

N. S. Bendre (1910–92)
Born in Indore, Madhya Pradesh, he attended the State School of Art, Indore, after completing his BA at Agra University. In 1940 he moved to Chennai to work as an art director for a film company. Between 1947 and 1950 he visited America, Europe, the Middle East and Japan. In New York he studied printmaking and on his return to India in 1950 he joined the Faculty of Fine Arts, M. S. University in Baroda. He was appointed Dean of the Faculty in 1959. He was President of the Art Society of India and Vice Chairman of the Lalit Kala Akademi (1962–72). In 1969 he was awarded the Padma Shri by the Government of India.

Veena Bhargava (b. 1938)
Born in Simla, Himachal Pradesh, she studied at the Government College of Arts and Crafts, Calcutta, and the Arts Students' League, New York. She was privately tutored by Paritosh Sen, who was a member of the Calcutta Group. She has had several solo shows in Mumbai, Calcutta and New Delhi

and has participated widely in group exhibitions, including the Fourth International Triennale, New Delhi (1978), *Centro Cultural*, Sao Laurneco, Portugal (1987) and *Wounds Exhibition*, CIMA Gallery, Calcutta, and National Gallery of Modern Art, New Delhi (1993). A recipient of the National Award, her works are exhibited in the National Gallery of Modern Art, New Delhi, the Tata Research Institute, Mumbai, Gallery Chemould, Mumbai, and the Birla Academy of Art and Culture, Calcutta. She presently lives and works in Calcutta.

Bikash Bhattacharjee (b. 1940)
Born in Calcutta, he received a diploma in Fine Arts from the Indian College of Arts and Draughtsmanship in 1963, and later taught at the same college from 1968 to 1973 before teaching at the Government College of Arts and Crafts. He has had several solo shows in India and internationally, including the Fourth Triennale, Paris (1969), *Contemporary Indian Art*, Royal Academy of Arts, London (1982), *India: Myth and Reality*, Museum of Modern Art, Oxford (1982), *Contemporary Indian Art*, Grey Art Gallery, New York (1985), and at the International Triennales in New Delhi. His work can be seen in several permanent collections, including those of the National Gallery of Modern Art, New Delhi, the Punjab University Museum, Chandigarh, and the Bharat Bhavan, Bhopal. He received the National Award in 1971 and 1972 and the Padma Shri in 1988. He now lives and works in Calcutta.

Rameshwar Broota (b. 1941)
Born in New Delhi, he received his diploma from the College of Art, New Delhi, in 1964. He has participated in a number of group shows including *Pictorial Space*, Lalit Kala Akademi, New Delhi (1977), *India: Myth and Reality*, Museum of Modern Art, Oxford (1982), *Modern Indian Paintings*, Hirshhorn Museum, Washington, D.C. (1982) and *Coups de Coeur*, Halles de l'Ile, Geneva (1987). He was also at the Biennales of Tokyo, Dacca and the International Art Fair, Cagnes-sur-Mer (1976). He is the Head of the Department of Art, Triveni Kala Sangam, New Delhi. In 1987 he was awarded a Senior Fellowship from the Ministry of Education, Government of India. He presently lives and works in New Delhi.

Sakti Burman (b. 1935)
Born in Calcutta, he studied at the Government College of Arts and Crafts in Calcutta and the Ecole Nationale des Beaux-Arts, Paris. Since 1954, he has had solo exhibitions all over the world. His works have been included in several group exhibitions such as *Contemporary Indian Art*, Yokohama (1993) and the *Salon d'Automne*, Grand Palais, Paris (1975) and have been shown in museums in France including the Musée de Blois and the Musée Denon, Châlon-sur-Sâone. He has participated in the Paris Biennales of 1963, 1965 and 1967. He lives and works in Paris.

Arpana Caur (b. 1954)
Born in Delhi, she received her degree in Literature from Delhi University. Since 1975 she has had several solo shows at, for instance, the Jehangir Gallery, Mumbai, the National Museum, Copenhagen, and Art Heritage, New Delhi. In 1995 she was commissioned by the Hiroshima Museum to execute a work to mark the 50th anniversary of the Holocaust. She has won a number of awards for her work in India and overseas. She lives and works in Delhi.

Jayashree Chakravorty (b. 1956)
Born in Agartala, Tripura, she received her BA in Fine Arts from Kala Bhavan, Vishwa Bharati University, Shantiniketan, and a Post Graduate diploma from M. S. University, Baroda. She has had several solo shows, and has also participated in group exhibitions including the *Exhibition of Arts* at the Festival of India, Stockholm (1987). A recipient of the AIFACS Award, Bombay Art Society award (1980), her works are on display at the National Gallery of Modern Art, New Delhi, and the Birla Academy of Art and Culture, Calcutta.

Avinash Chandra (1931–91)
Born in Simla, Himachal Pradesh, he received his diploma in painting from the Delhi Polytechnic in 1952 and then joined the staff until he moved to London in 1956. After his first solo show in 1951 in Srinagar, he exhibited at the Imperial Institute and Architectural Association in London and the National Gallery of Ireland, Dublin, as well as in Belfast, Paris, Amsterdam, Zurich, Copenhagen and Stockholm. He was the first Indian artist to exhibit at the *Documenta* in Kasel, Germany (1964), following which he showed in America, Canada and Israel and in *The Other Story*, Hayward Gallery, London (1989). His work forms part of the collections of the Tate Gallery, London, National Gallery of Modern Art, New Delhi, the Victoria and Albert Museum, London, the Musée d'Art Moderne, Paris, the Museum of Modern Art, Berlin, and in New York University, as well as many private collections.

Bal Chhabda (b. 1924)
Born in the Punjab, he is a self-taught artist. He has participated in a number of group exhibitions at, for instance, the Musée National d'Art Moderne, Paris (1960), Tokyo Biennale, Japan (1961), where he was awarded the Tokyo Governor's Award, the First, Third and Fifth International Triennales, New Delhi (1968, 1975, 1982), *Art Now in India*, London and Newcastle-upon-Tyne (1965) and the inaugural exhibition of the Museum of Modern Art, Japan (1969). In 1966 he received the Lalit Kala Akademi Award and in 1972 was awarded the J. D. Rockefeller III Fund Fellowship. He presently lives and works in Mumbai.

Jogen Chowdhury (b. 1939)
Born at Faridpur, Bengal, he graduated from the Government College of Arts and Crafts, Calcutta. In 1965 he received a scholarship from the French Government to study at the Ecole Nationale Supérieure des Beaux-Arts, Paris, and the Atelier 17. He returned to India in 1970, and in 1972 was appointed curator of Rashtrapati Bhavan in New Delhi. His work features in the collections of the National Gallery of Modern Art, New Delhi, the Galerie de Haut Pave, Paris, the Victoria and Albert Museum, London, and the Bharat Bhavan in Bhopal. He took part in prestigious exhibitions such as *Modern Asian Art*, Fukuoka Museum, Japan (1979), *Place for People*, Jehangir Art Gallery, Mumbai (1981), *Contemporary Indian Art*, Royal Academy of Arts, London (1982), *Modern Indian Paintings*, Hirshhorn Museum, Washington, D.C. (1982), *Artistes Indiens en France*, Centre National des Arts Plastiques, Paris (1985), *Contemporary Indian Art*, Grey Art Gallery, New York (1985), and *Coups de Coeur*, Halles de l'Ile, Geneva (1987). He is also a poet. He now resides and works in Shantiniketan.

Sunil Das (b. 1939)
Born in Calcutta, he studied at the Government College of Arts and Crafts, Calcutta, the Ecole Nationale Supérieure des Beaux-Arts and at Atelier 17. He has had several solo exhibitions and has participated in group exhibitions in Paris, New Delhi, Calcutta, Germany, New York and Switzerland. Most notably his work was shown at the Second International Triennale, New Delhi (1971) and the Brazil Biennale (1991). A recipient of the National Award in 1959 and 1978 and the Shiromoni Puroskar in 1991, his works can be seen in the Lalit Kala Akademi, New Delhi, the National Gallery of Modern Art, New Delhi, and in Paris at the Galerie René Bretent, Galerie Marcel Adler and Galerie Wils.

Dharmanarayan Das Gupta (b. 1939)
Born in Tripura, he studied at the Kala Bhavan, Shantiniketan, and is currently Dean of the Faculty of Visual Arts, Rabindra Bharati University, Calcutta. He has had solo shows in Calcutta, Chennai and New Delhi, and has also participated in several group exhibitions including the Sixth International Triennale, New Delhi (1986), Bharat Biennale, Bhopal (1986), Havana Biennale, Cuba (1986) and the 19th Sao Paulo Biennale (1987). His works are on display at the Lalit Kala Akademi, New Delhi, National Gallery of Modern Art, New Delhi, Birla Academy of Art and Culture, Calcutta, and the Victoria and Albert Museum, London. He presently lives and works in Shantiniketan.

Biren De (b. 1926)
Based in Delhi, De received his diploma in Fine Arts from the Government College of Arts and Crafts, Calcutta, in 1949. He lectured at the College of Art, New Delhi, and in 1959 he received a Fullbright Grant and so for some time lived and worked in New York. He represented India at the Venice Biennale (1962) and at the Salon de Mai, Paris (1951). His works also form part of the permanent collections of the National Gallery of Modern Art, New Delhi, the Berlin State Museum and the National Gallery, Prague, as well as other major international museums.

C. Douglas (b. 1951)
Born in Kerala, India, he received a diploma from the Government College of Arts and Crafts, Chennai. He has had solo shows in Germany, the Netherlands and India and has also participated widely in group exhibitions. He received the Charles Wallace grant in 1994 and the National Award for Painting in 1992.

H. A. Gade (b. 1917)
Born in Talegaon, Maharashtra, he was awarded a Diploma in Fine Arts in 1949 from the Nagpur School of Art and his MA the following year. His first exhibition was held with the Progressive Artists' Group in 1948 and in 1949 he showed at the Salon de Mai, Paris. In 1957 he was awarded the Bombay Art Society's Gold Medal and was invited to participate in the Venice Biennale. His work was recently shown at *The Moderns*, inaugural exhibition of the National Gallery of Modern Art, Mumbai (1997). He lives and works in Mumbai.

V. S. Gaitonde (b. 1924)
Born in Nagpur, Maharashtra, he studied at the Sir J. J. School of Art, Mumbai, and was associated with the Progressive Artists' Group in its last phase. In 1964 he travelled to America on a Rockefeller Fellowship and had a solo show in New York. He has participated in major international exhibitions, including *Young Asian Artists*,

Tokyo (1957) and *Contemporary Indian Art*, Royal Academy of Arts, London (1982). In 1971 the Government of India awarded him a Padma Shri. He lives and works in Delhi.

Jaya Ganguly (b. 1958)
Born in Calcutta, she received a diploma in Painting from the Indian College of Arts and Draughtsmanship, Calcutta, in 1983. Since then she has had solo exhibitions in Calcutta and New Delhi. In addition, she participated in the *Festival of India*, Stockholm (1987). Her paintings are in the permanent collections of the National Gallery of Modern Art, New Delhi, and the Birla Academy of Art and Culture, Calcutta. She currently lives in Calcutta.

Laxma Goud (b. 1940)
Born in Nizampur, Andhra Pradesh, he trained at the College of Fine Arts and Architecture in Hyderabad. In 1963 he won a scholarship to study mural painting at the Faculty of Fine Arts, M. S. University in Baroda, where he became a student of K. G. Subramanyan and specialized in printmaking. His first solo show was held in 1965 and further exhibitions of his drawings, watercolours and prints followed in Delhi, Mumbai and Bangalore. His work was included in the *Contemporary Indian Art* exhibition at the Royal Academy of Arts, London (1982) and in group shows in Calcutta, Delhi and Chennai (1984). His paintings are in the permanent collections of the National Gallery of Modern Art, New Delhi, the Lalit Kala Akademi, New Delhi, the Salajung Museum, Hyderabad, and the Punjab University Museum, Chandigarh. He presently lives in Hyderabad and works as a printmaker and a graphic artist for television.

Satish Gujral (b. 1925)
Born in Jhelum, the Punjab, he studied at the Mayo School of Art, Lahore, and at the Sir J. J. School of Art, Mumbai. Between 1952 and 1954 he worked under David Alfaro Siqueiros at the Palacio Nazionale de Bellas Artes in Mexico City. He returned to India and began working with paint and paper collage, clay and ceramic, wood, metal and glass. He has also designed murals and worked as an architect. His most famous commission was the Belgian Embassy, New Delhi. He has participated in several important international exhibitions including *Contemporary Art: A Dialogue between East and West*, National Museum of Modern Art, Tokyo (1969), *Pictorial Space*, Lalit Kala Akademi, New Delhi (1977), *India: Myth and Reality*, Museum of Modern Art, Oxford (1982) and *Contemporary Indian Art*, Royal Academy of Arts, London (1982). His work has been presented at the Biennales of Venice, Tokyo and Sao Paulo. He was awarded the Order of the Crown from Belgium for his achievements in architecture. He lives and works in New Delhi.

Ganesh Haloi (b. 1936)
Born in Calcutta, he studied at the Government College of Arts and Crafts, Calcutta. He has had several solo shows in India, for instance, in Delhi, Mumbai and Calcutta, and has participated in various group exhibitions including *Indian Contemporary Artists – Multiculturalism and Internationalism through Art*, Melbourne (1991) and Bose Pacia Modern, New York (1995). His works are on display at the Bharat Bhavan, Bhopal, the Singapore Museum and the National Gallery of Modern Art, New Delhi. In 1955 he was awarded the Latham Foundation, USA, award. He is visiting Professor at Kala Bhavan, Vishwa Bharati University, Shantiniketan, and Reader at the Government College of Arts and Crafts, Calcutta. He presently lives and works in Calcutta.

K. K. Hebbar (1911–96)
Born in Karnataka, India, he studied at the Sir J. J. School of Art, Mumbai. He taught at his Alma Mater before pursuing a course in painting at the Académie Julian, Paris. Between 1949 and 1950, he had a solo show in Paris and London and in 1951 participated in the Salon de Mai. He was awarded a Gold Medal by the Bombay Art Society in 1947 and the Lalit Kala Akademi National Award three years running from 1956. He represented India at the Sao Paulo Biennale and was awarded the Padma Bhushan by the Government of India in 1989.

Somnath Hore (b. 1921)
Born in Chittagong, he began his career in newspapers as a political illustrator. In 1946 he attended the Government School of Art in Calcutta, specializing in woodcut printing, but joined the Communist Party in 1947, which affected his formal training. In 1958 he moved to Delhi and took up a post at the Delhi Polytechnic. He explored various new techniques and under his guidance the graphic department flourished. He was greatly influenced by the work of Krishna Reddy. In 1958, 1962 and 1963 he won national awards. He now resides in Shantiniketan.

M. F. Husain (b. 1915)
Born in Pandharpur, Maharashtra, he is largely a self-taught artist, who began his career painting cinema posters soon after he moved to Mumbai in 1936. In 1947 he exhibited for the first time with a group of artists, including S. H. Raza and K. H. Ara, who together with F. N. Souza founded the Progressive Artists' Group. His paintings were shown at the Biennale in Sao Paulo (1971), where he was an invited guest along with Picasso, and *India: Myth and Reality*, Museum of Modern Art, Oxford (1982), *Modern Indian Paintings*, Hirshhorn Museum, Washington, D.C. (1982) and *Six Indian Painters*, Tate Gallery, London (1982). He has also made twelve short films and was the recipient of the Golden Bear Award at the Berlin Film Festival in 1967. He was nominated to the Raj Sabha (upper house of Parliament) in 1986. He received the Padma Bibhushan in 1989. Today he mostly lives in Mumbai, but also in Delhi.

Shamshad Husain (b. 1946)
Born in Mumbai, he studied at the College of Fine Arts, Baroda, and later at the Royal College of Art, London. A prolific artist, he has had more than thirty solo shows, the first in 1968, and has participated in several international exhibitions, including the *Royal College of Art Annual Exhibition*, Royal College of Art, London (1980) and *Asian Art*, Fukuoka Museum, Japan (1985). His work has been presented at the Biennales of Tokyo, Dacca, Ankara and Bhopal. He lives and works in New Delhi.

Anish Kapoor (b. 1954)
Born in Mumbai, he studied at Hornsey College of Art, London, between 1973 and 1977 and at Chelsea School of Art, London, until 1978. He began teaching at Wolverhampton Polytechnic in 1979 and became Artist-in-Residence at the Walker Art Gallery, Liverpool, in 1982. He has had more than twenty solo shows in Paris, New York, Liverpool and London and has taken part in major group shows in Britain and the Venice Biennale (1982 and 1990). He received the Turner Prize in 1991 and an Honorary Fellowship at the London Institute in 1997. He lives and works in London.

Prokash Karmakar (b. 1934)
Born in Calcutta, he studied Fine Arts at the Government College of Arts and Crafts, Calcutta, and later trained in Paris on a French Government Fellowship. He was a founder member of the Society of Contemporary Artists, the Calcutta Painters and the Calcutta Art Fair. He has had several solo shows in Calcutta, New Delhi, Mumbai, Paris, Bonn, Antwerp and Geneva. He also participated in the Sao Paulo Biennale (1962), Second International Triennale, New Delhi (1971) and the Asian Biennale, Bangladesh (1991). He received the Lalit Kala Akademi National Award in 1966 and the Birla Academy of Art and Culture Award in 1973. His works are exhibited in the Lalit Kala Akademi, New Delhi, and the National Gallery of Modern Art, New Delhi.

Bhupen Khakhar (b. 1934)
Born in Mumbai, he initially trained as an accountant. After studying art, he changed careers and joined the Faculty of Fine Arts, M. S. University, Baroda. He held his first solo show in Mumbai in 1965. He has also participated in various group exhibitions, among them *Art Now in India*, London and Newcastle-upon-Tyne (1965), *Pictorial Space*, Lalit Kala Akademi, New Delhi (1977) and *Contemporary Indian Art*, Royal Academy of Arts, London (1982). More recently, he participated in the exhibition *Indian Songs*, Perth, Australia (1994). His work is represented at the National Gallery of Modern Art, New Delhi, Lalit Kala Akademi, New Delhi, Punjab University Museum, Chandigarh, the British Museum, London, and the Museum of Modern Art, New York. He is an accomplished short story writer and playwright, and in 1984 was awarded the Padma Shri.

Balraj Khanna (b. 1940)
Born in the Punjab, he received his MA in English Literature from Punjab University in 1962. He moved to Britain the same year for further studies but instead took up painting. Since 1965 he has had over forty solo shows in many cities, including London, Paris, New York, Berlin, Frankfurt, Edinburgh and New Delhi. His paintings have been shown in several international exhibitions. His work is part of the permanent collections of the Arts Council of England, the Victoria and Albert Museum, London, De Beers Collection, London, Ashmolean Museum, Oxford, Musée d'Art Moderne, Paris, and Ville de Paris, Calloust Gulbenkian Foundation, Lisbon, Museum of Modern Art, Machynlleth, Wales, and the National Gallery of Modern Art, New Delhi. In 1985 he was awarded the Winifred Holtby Memorial Prize by the Royal Society of Literature for his first novel *Nation of Fools*. His book on Indian art, *Kalighat Paintings 1800–1930*, received critical acclaim. He lives and works in London.

Krishen Khanna (b. 1925)
Born in Lyallpur, the Punjab, he graduated in English Literature from Government College, Lahore. A self-taught painter, he gave up his banking career in 1961 to pursue painting. A fellowship from the Rockefeller Council enabled him to travel across the world. In 1962 he was invited to the American University, Washington, D.C., as Artist-in-Residence. In 1965, he was awarded the Lalit Kala National Award. He has had numerous solo shows in India and abroad and has also participated in various group shows including *Contemporary Art from India*, Essen, Dortmund and Zurich (1960), *Contemporary Art: A Dialogue between East and West*, National Museum of Modern Art, Tokyo (1969), *Pictorial Space*, Lalit Kala Akademi, New Delhi (1977), *India: Myth and Reality*, Museum of Modern Art, Oxford (1982), *Modern Indian Paintings*, Hirshhorn Museum, Washington, D.C. (1982) and *Coups de Coeur*, Halles de l'Ile, Geneva (1987). His work has been presented in the Biennales of Sao Paulo (1961), Venice (1962) and Tokyo (1957, 1961). He was a lecturer on art at the Jawaharlal Nehru University, New Delhi. He lives and works in Delhi.

Ram Kumar (b. 1924)
Born in Simla, Himachal Pradesh, he received an MA in Economics from Delhi University. In 1950 he studied briefly at the ateliers of André Lhote and Fernand Léger in Paris where he came into contact with left-wing intellectuals such as Louis Aragon and Paul Eluard. He returned to India and worked for the Peace Movement and in 1969 travelled to America and Mexico on a Rockefeller Fellowship. He has had over thirty-five solo exhibitions in India. He has also participated in group shows such as *Art Now in India*, London and Newcastle-upon-Tyne (1965), *Contemporary Indian Art*, Royal Academy of Arts, London (1982), *Artistes Indiens en France*, Centre National des Arts Plastiques, Paris (1985), *Coups de Coeur*, Halles de l'Ile, Geneva (1987), *National Exhibition of Contemporary Art*, National Gallery of Modern Art, New Delhi (1995). His work was also shown at the Venice Biennale in 1958. He is a renowned Hindi writer and now lives and works in Delhi.

Chitravanu Mazumdar (b. 1956)
Born in Paris, she graduated from the Government College of Arts and Crafts, Calcutta, in 1981. She has had exhibitions at the Academy of Fine Arts, Calcutta (1985), Birla Academy of Art

and Culture, Calcutta (1987), Jehangir Art Gallery, Mumbai (1989) and the Lalit Kala Akademi, New Delhi (1994). She has participated widely in group exhibitions, including *Salon d'Automne*, Grand Palais, Paris (1994) and the Birla Academy Annual Exhibitions, Calcutta. Her paintings are exhibited in the National Gallery, New Delhi, and the Birla Academy of Art and Culture, Calcutta.

Tyeb Mehta (b. 1925)

Born in Kapadvanj, Gujarat, he studied at the Sir J. J. School of Art, Mumbai. From 1959 to 1964 he lived in London. He has participated in various exhibitions, including *Art Now in India*, London and Newcastle-upon-Tyne (1965), *India: Myth and Reality*, Museum of Modern Art, Oxford (1982) and *Coups de Coeur*, Halles de l'Ile, Geneva (1987). He has had solo exhibitions at Gallery One, London (1962), Bharat Bhavan, Bhopal (1988) and Art Heritage, New Delhi (1990). In 1965 he received the National Award. He currently lives and works in Mumbai.

Anjolie Ela Menon (b. 1940)

Born in West Bengal, she had a brief spell at the Sir J. J. School of Art, Mumbai, before going on to Delhi University where she studied English Literature. After holding exhibitions in Mumbai and Delhi in the late 1950s, she won a French Government scholarship to the Ecole Nationale des Beaux-Arts, Paris. Before returning home, she travelled extensively in Europe and West Asia, studying Romanesque and Byzantine art. Since then she has lived in India, Britain, America, Germany and Russia. She has had over thirty solo shows culminating in a retrospective exhibition in 1988 in Mumbai, and has participated in several international group shows. She is a well-known muralist and has represented India at the Biennales of Algiers and

Sao Paulo. She has served on the Advisory Committee and Art Purchase Committee of the National Gallery of Modern Art, New Delhi, where she was co-curator for a major exhibition of French contemporary art in 1997. She lives and works in New Delhi.

Dhruva Mistry (b. 1957)

Born in Gujarat, India, he studied sculpture at the M. S. University, Baroda, and the Royal College of Art, London. He represented Britain at the *Third Rodin Grand Prize Exhibition*, Japan (1990), and was elected a Fellow of the Royal Society of British Sculptors. He has had numerous solo shows in London and has participated in several major exhibitions, including the Fifth International Triennale, New Delhi (1982), *A Journey through Contemporary Art*, Hayward Gallery, London (1985), *Summer Exhibition*, Royal Academy of Arts, London (1996) and *ART 96, The London Contemporary Art Fair*, London (1996). He is also represented in the permanent collections of the City Museum and Art Gallery, Birmingham, the City Art Gallery, Manchester, Fukuoka Art Museum, Japan, National Museum of Wales, Cardiff, Roopankar Musuem, Bhopal, Tate Gallery, London, the British Council and the Victoria and Albert Museum, London. He presently lives and works in London.

Meera Mukherjee (b. 1923)

Born in Calcutta, she trained at the Indian Society of Oriental Arts, Delhi Polytechnic and at the Akademie de Bildenden Kunsten in Munich. She imbibed the traditional skills of metal casting from the Bastar Gharuas tribe and other master craftsmen in West Bengal, Bihar and Orissa. She has had several solo shows in Germany and at the Max Mueller Bhavan, Calcutta (1960) and Gallery Chemould, Calcutta (1966).

A recipient of the President's Award for Master Craftsmen in Metalwork, she was also given the Abanindranath Award by the West Bengal Government in 1980. She has published several books on art.

Mrinalini Mukherjee (b. 1949)

Born in Mumbai, she studied at the Faculty of Fine Arts at M. S. University, Baroda, and subsequently did a post-graduate Diploma in mural design under K. G. Subramanyan. She was awarded a British Council scholarship for sculpture and worked at the West Surrey College of Art and Design in Farnham from 1971 until 1978. Since 1972 she has participated in over forty solo and group exhibitions in India and abroad, most notably, *India: Myth and Reality*, Museum of Modern Art, Oxford (1982), *Contemporary Indian Art*, Royal Academy of Arts, London (1982), *Indian Contemporary Art*, Japan (1988) and *The Asia Pacific Triennial of Contemporary Art*, Australia (1996). She was awarded the All India Fine Arts and Crafts Award and Medal, New Delhi (1975), and the National Award for Sculpture, New Delhi (1976). She presently lives and works in New Delhi.

Akbar Padamsee (b. 1928)

Born in Mumbai, he studied at the Sir J. J. School of Art, Mumbai. He left for Paris after his studies and in 1965 travelled to New York on a Rockefeller fellowship. He returned to India in 1967 and was awarded the Nehru Fellowship in 1969. He established the Vision Exchange Workshop for artists and film-makers and also made short films, including *SYZYGY*, which animates a set of his geometrical drawings. He has had several solo exhibitions in India, culminating in retrospectives in Mumbai and Delhi (1980). His important group exhibitions include *India: Myth and Reality*, Museum of Modern Art, Oxford

(1982), *Contemporary Indian Art*, Royal Academy of Arts, London (1982) and *Artistes Indiens en France*, Centre National des Arts Plastiques, Paris (1985). He has exhibited at the Biennales of Venice, Sao Paulo and Tokyo. He lives and works in Mumbai.

Laxman Pai (b. 1926)
Born in Goa, he studied at the Sir J. J. School of Art, Mumbai. From 1951 he lived and worked in Paris for ten years and during that period exhibited in, among other cities, London, Munich, Stuttgart and New York. He participated in the Biennale Sao Paulo, Brazil. A recipient of the Lalit Kala Akademi national awards in 1961, 1963 and 1972, his works are in the permanent collections of the Musée d'Art Moderne, Paris, National Gallery of Modern Art, New Delhi, and the Berlin Museum. He presently lives and works in Delhi.

Shanti Panchal (b. 1951)
Born in Gujarat, he studied at the Sir J. J. School of Art, Mumbai, and Byam Shaw School of Art, London. He has had many solo exhibitions in India and in Britain, most notably at the Museum of Modern Art, Oxford (1992–93), and has also taken part in numerous group exhibitions. His work is part of the permanent collections at the Imperial War Museum and the British Museum, London, the Bradford Art Gallery and Museum, and the Lalit Kala Akademi, Ahmadabad. In 1991 he won the BP Portrait Award from the National Portrait Gallery, London.

Manu Parekh (b. 1939)
Born in Ahmadabad, he studied at the Sir J. J. School of Art, Mumbai (1962). He has participated in several group shows including the Third and Fourth International Triennales, New Delhi (1975, 1978), *Modern Indian Paintings*, Hirshhorn Museum, Washington,

D.C. (1982), and, in addition, has had a number of solo exhibitions. A recipient of the Lalit Kala Akademi national award in 1982, he was also awarded the Padma Shri in 1991.

Gieve Patel (b. 1940)
Born in Mumbai, he qualified as a doctor and was also a writer and art critic for the *Times of India*. He held his first solo show in 1966 and has participated in many major international exhibitions, including *Contemporary Indian Art*, Royal Academy of Arts, London (1982), *India: Myth and Reality*, Museum of Modern Art, Oxford (1982) and *Contemporary Indian Art*, Grey Art Gallery, New York (1985). The National Gallery of Modern Art, New Delhi, the Museum of Modern Art, New York, the Musée de Menton, France, and the Bharat Bhavan, Bhopal, all have his work in their collections. He has published two volumes of his poetry. He presently lives in Mumbai, where he continues to practise medicine and to paint.

Trupti Patel (b. 1957)
Born in Nairobi, she studied at the M. S. University of Baroda and the Royal College of Art, London, on a British Council Scholarship. She has had solo shows at Hatheesing Art Gallery, Ahmadabad (1983), the Museum of Mankind, London (1986), and the Hannah Peschar Gallery, Surrey (1995). She participated in the *First Triennale of Small Ceramics*, the Former Yugoslavia and the Museum of Mankind, London (1984), *Works in Clay*, Nigel Greenwood Gallery, London (1986), *Human Zoo*, Nottingham Castle Museum, Nottingham (1986), *Clay Bodies*, Museum of Modern Art, Oxford (1994), *Sculpture at Canterbury*, Herbert Read Gallery, Canterbury (1994) and *Summer Exhibition*, Royal Academy of Arts, London (1994). She is also represented

in the permanent collections of the British Council, London, the Victoria and Albert Museum, London, the Kanoria Art Centre, Ahmadabad, and the Shigaraki Ceramic Sculpture Park, Japan. In 1984 she was awarded the Charles Wallace India Trust Award.

Sudhir Patwardhan (b. 1949)
Born in Pune, Maharashtra, he initially studied medicine at university and later became a self-taught painter. He first exhibited his paintings in 1979 in Delhi, Mumbai, and Bhopal, and participated in numerous group exhibitions, such as *Place for People*, Jehangir Art Gallery, Mumbai (1981), *India: Myth and Reality*, Museum of Modern Art, Oxford (1982), *The Festival of India*, London (1982), New York (1985) and Paris (1986), and *Coups de Coeur*, Halles de l'Ile, Geneva (1987). His works are represented in several museums, including the Punjab University Museum, Chandigarh, the Roopankar Museum, Bhopal, and the National Gallery of Modern Art, New Delhi. He presently lives in Thane, on the outskirts of Mumbai.

Ganesh Pyne (b. 1937)
Born in Calcutta, he graduated with a diploma from the Government College of Arts and Crafts in 1959. He has experimented with various media and his works are mainly in small format, but have a remarkable intensity. He has deliberately never held any solo shows, but has participated in numerous group exhibitions, including the First International Triennale, New Delhi (1968), the Paris Biennale (1969), and the Second International Triennale, New Delhi (1971). He received the Birla Academy of Art and Culture Award in 1973 and Shiromoni Purashkar in 1985. His works are part of the collections of the National Gallery of Modern Art, New Delhi, the Academy of Fine Arts,

Calcutta, the Lalit Kala Akademi, New Delhi, and are in various private collections in India and abroad.

A. Ramachandran (b. 1935)

Born in Attingal, Kerala, he did his MA in Malayalam Literature at Kerala University before going to Shantiniketan to study art. Between 1961 and 1964 he worked on a research project on the mural paintings of Kerala. Since his first exhibition in 1966, he has had several solo shows and retrospectives in both Delhi and Mumbai. He has also participated in some important exhibitions including *Pictorial Space*, Lalit Kala Akademi, New Delhi (1977), *Contemporary Indian Art*, Royal Academy of Arts, London (1982), *India: Myth and Reality*, Museum of Modern Art, Oxford (1982) and *Modern Indian Paintings*, Hirshhorn Museum, Washington, D.C. (1982). His work has been presented at the Biennales of Tokyo, Menton, Sao Paulo and Havana. He has written and illustrated about fifty children's picture books for which he received the Noma Concours awards in 1978 and 1980. He lives and works in New Delhi.

Raja Ravi Varma (1848–1906)

Born in Kilimanoor, Kerala, he was educated at home and received his first painting lesson from his uncle Raja Raja Varma, although on the whole he was self-taught. In 1873 he submitted two paintings to the Fine Arts Exhibition in Madras and won the Governor's Gold Medal for *Nair Lady Adorning Her Hair*. The subjects of his paintings were often drawn from the Indian epics and his works are said to have influenced the popular Indian Bollywood film industry much as Victorian art inspired some Hollywood directors. He has been credited as being the first Indian artist to apply the traditions of Western realistic art to the representations of Indian

mythology. He was also a well-known portraitist and received commissions from a number of princely families as well as Europeans living in India. His works are part of the collections of the National Gallery of Modern Art, New Delhi, the Sri Chitra Art Gallery, Thiruvanathapuram, and the Prince of Wales Museum, Mumbai. The *New Perspectives* exhibition at the National Museum, New Delhi (1993) displayed a large number of his paintings, drawings, watercolours and oleographs.

S. H. Raza (b. 1922)

Born in Babaria, Madhya Pradesh, he studied first at Nagpur, and later at the Sir J. J. School of Art in Mumbai. He was a founding member of the Progressive Artists' Group. The French Government granted him a scholarship in 1950 to study at the Ecole Nationale des Beaux-Arts in Paris for three years. He won the Prix de la Critique in 1956 and in 1962 became a visiting lecturer at the University of California at Berkeley. He has participated in the Biennales of Venice (1956), Paris (1957), Bruges and Sao Paulo (1958), Morocco (1963), Menton (from 1964), the *Commonwealth Exhibition*, Commonwealth Institute, London (1962), *Contemporary Indian Painting*, Royal Academy of Arts, London (1982), Centre National des Arts Plastiques, Paris (1985) and *Contemporary Indian Art*, Grey Art Gallery, New York (1985). He has had numerous solo shows and is also represented in the permanent collections of the National Gallery of Modern Art, New Delhi, the Musée National d'Art Moderne, Paris, the Asia Society, New York, and the Musée de Menton, France. He mainly lives and works in Paris with his French wife, the artist Janine Mongillat.

Krishna Reddy (b. 1925)

Born in Andhra Pradesh, he received his first diploma in Fine Arts from the International University in Shantiniketan. He has participated in numerous international exhibitions including the Fifth International Triennale, New Delhi (1982), and many art exhibitions in America, where he has lived for many years. In 1972 he was awarded the title of Padma Shri in India and in 1976 he was chosen as one of thirty-three international artists for a portfolio of prints for the *Hommage aux Prix Nobel* series in Sweden. In 1981 there was a major retrospective at the Bronx Museum of the Arts, New York, and simultaneous exhibitions were held at Gallery Chemould branches in India. He has published various articles for the Lalit Kala Contemporary series, and has written on Rabindranath Tagore and also the Surrealist movement. He lives in America.

N. N. Rimzon (b. 1957)

Born in Kakkoor, Kerala, he studied sculpture at the College of Fine Arts, Trivandrum, graduating in 1982, and received an MA in Sculpture from the M. S. University of Baroda in 1984, and later an MA from the Royal College of Arts, London, in 1989. His solo shows include *Recent Sculpture and Drawings*, Art Heritage, New Delhi (1991), and an exhibition at Gallery Schoo (FIA), Amsterdam (1994). He has participated in several group exhibitions including, *Six Contemporary Artists from India*, Centre d'Art Contemporain, Geneva (1987), *A Critical Difference: Contemporary Art from India*, Camden Arts Centre, London, and touring (1993), *A Hundred Years from the National Gallery of Modern Art Collection*, New Delhi (1994) and *Traditions/Tensions: Contemporary Art in Asia*, The Asia Society, New York (1996). He lives and works in Delhi.

Rekha Rodwittiya (b. 1958)
Born in Bangalore, she graduated
from the Faculty of Fine Arts, M. S.
University, Baroda, and in 1981 received
the Inlaks Scholarship of the Shivdasani
family enabling her to continue her
studies in London. She received her MA
of Fine Arts from the Royal College of
Art, London, and in 1983, her last year
in Britain, was awarded the Unilever
Prize. She held her first solo exhibition
in Baroda in 1981 at the Urja Art Gallery,
and others in Delhi, Mumbai, Chennai
and Stockholm followed. She has also
participated in various group exhibitions
including the Second Biennale, Havana
(1987) and *Six Young Contemporaries*,
Geneva (1987). In 1990 she received
a Staff Fellowship from the Rockefeller
Foundation Asian Cultural Council
which enabled her to spend time painting
in New York. She presently lives and
works in Baroda.

Indrapramit Roy (b. 1964)
Born in Calcutta, he graduated from
Shantiniketan, and received a post-
graduate degree in Painting from M. S.
University, Baroda, and in Fine Arts
from the Royal College of Art, London.
Some of the group exhibitions that he
has taken part in include *On Sight*, Tower
Bridge Piazza, London (1991), *In Sight*,
Royal College of Art, London (1992), *Off
Sight*, Cooling Gallery, London (1992)
and *Trends in Contemporary Indian Art*,
Art Heritage, New Delhi (1994). He has
had several solo exhibitions in India at,
among others, Gallery 7, Mumbai (1993,
1995) and Galerie 88, Calcutta (1994). In
1992 he was awarded the Burston Award
and the Fleur Cowles Annual Award for
Excellence. He lives in Calcutta.

Jamini Roy (1887–1972)
Born in Bengal, of a middle-class
landowning family, he was sent at an
early age to study at the Government

School of Art, Calcutta, and had his first
exhibition there in 1929. In 1955 he was
awarded the Padma Bhusan. He always
worked in or near Calcutta, where he
died in 1972.

Jahangir Sabavala (b. 1922)
Born in Mumbai, he studied at the Sir J. J.
School of Art, Mumbai, the Academy
Heatherley School of Art, London,
the Académie Julian, the Académie
André Lhote and the Académie de la
Grande Chaumière, Paris. Since his
first exhibition in 1951, he has had more
than twenty-five solo shows. He has also
participated in important exhibitions
including *Art Now in India*, London and
Newcastle-upon-Tyne (1965), *Asian
Artists Exhibition*, Fukuoka Museum,
Japan (1979) and *Modern Indian Paintings*,
Hirshhorn Museum, Washington, D.C.
(1982). In 1980 *The Reasoning Vision:
Jehangir Sabavala's Painterly Universe*
was published and in 1984 the Lalit
Kala Akademi published the monograph
Jehangir Sabavala. A film on his life and
work, *Colours of Absence*, won the National
Award in 1994. He was awarded the
Padma Shri by the Government of India
in 1977. He lives and works in Mumbai.

G. R. Santosh (1929–96)
Born in Kashmir, he won a government
scholarship to study Fine Arts at Baroda
University under N. S. Bendre. He held
his first solo exhibition in Srinagar in
1953 and later exhibited in America,
Canada, Japan, Hong Kong and
Singapore, and participated in group
shows notably the Sao Paulo Biennale
(1969 and 1972), the First and Fourth
International Triennales, New Delhi
(1968 and 1978), *Contemporary Indian Art*,
National Gallery of Modern Art, New
Delhi (1984) and *Neo-Tantric Art*, UCLA,
Los Angeles (1986). He received the
National Award in 1973, the Padma Shri
in 1977, and the Artist of the Year Award

in New Delhi in 1984. In 1979 he was the
recipient of the Sahitya Akademi Award
for his collection of poems, *Besukh Ruh*.

Lalu Prasad Shaw (b. 1937)
Born in Suri, West Bengal, he graduated
from the Government College of Art,
Calcutta. A member of the Society of
Contemporary Artists, Calcutta, he
has had several solo exhibitions in New
Delhi, Calcutta and Chennai, and has
also participated in group exhibitions
in Prague and Texas. A recipient of
the Lalit Kala Akademi National Award
in 1971, the Birla Academy of Art and
Culture Award (1976–78), his works can
be seen in the National Gallery and the
Lalit Kala Akademi, New Delhi.

Gulam Mohammed Sheikh (b. 1937)
Born in Surendrangar, Saurashtra, he
received his MA in Fine Arts from the
M. S. University of Baroda. In 1963 he
took part in the foundation of Group
1890 and attended the Royal College of
Art, London. He travelled extensively in
Europe, studied early Italian painting
and in 1966 returned to India and began
his career teaching at his Alma Mater.
He played an active role in the Artists'
Protest Movement as editor of *Vrscika*
from 1969 until 1973. He has had several
solo exhibitions and has participated
in some important national and
international exhibitions including
Pictorial Space, Lalit Kala Akademi, New
Delhi (1977), *Place for People*, Jehangir Art
Gallery, Mumbai (1981), *Contemporary
Indian Art*, Royal Academy of Arts,
London (1982), *Modern Indian Paintings*,
Hirshhorn Museum, Washington, D.C.
(1982) and *Contemporary Indian Artists*,
Centre Georges Pompidou, Paris (1986).
He was awarded the Padma Shri by the
Government of India in 1983. He lives
and works in Baroda.

Amrita Sher-Gil (1913–41)
Born in Budapest, her father was a
Sikh aristocrat and her mother was
Hungarian. She was brought up in Simla
and Saraya, a village in the Gorakhpur
district of Uttar Pradesh. In 1924 she
was sent to school in Florence for a short
period and in 1929 went to study art in
Paris under Pierre Vaillant at the Grande
Chaumière and also under Lucien Simon
at the Ecole des Beaux-Arts. She returned
to India in 1934 and until 1941 painted
prolifically with pictures such as *Bride's
Toilet* and *Hill Women* establishing her
reputation as an artist of the highest rank.
She moved to Lahore with her husband,
Dr Victor Egan, and enjoyed the cultural
milieu there. She was deeply committed
to various movements including the
national freedom struggle within British
India. She was suddenly taken ill in 1941
and died on 5 December. She is regarded
as one of the greatest and earliest
pioneers of contemporary art in India.

Arpita Singh (b. 1937)
Born in West Bengal, she studied at
the School of Art, New Delhi, prior to
becoming an art designer at the Weavers'
Service Centres in Calcutta and Delhi.
She held her first solo exhibition in
1972, and since then her work has been
exhibited extensively, most notably
in *Pictorial Space*, Lalit Kala Akademi,
New Delhi (1977), *Contemporary Indian
Art*, Royal Academy of Arts, London
(1982), *Three Painters*, Centre Georges
Pompidou, Paris (1986), *Coups de Coeur*,
Halles de l'Ile, Geneva (1987) and *Indian
Songs*, Art Gallery of New South Wales,
Sydney (1993). Her work is represented
in the permanent collections of the
National Gallery of Modern Art, New
Delhi, Lalit Kala Akademi, New Delhi,
Chandigarh Museum, Bharat Bhavan,
Bhopal, and the Victoria and Albert
Museum, London. She currently lives
and works in New Delhi.

Paramjit Singh (b. 1935)
Born in Amritsar, he graduated in
Fine Arts from the School of Art, Delhi
Polytechnic in 1958. A founder member
of The Unknown – a group of young
painters and sculptors from Delhi – he
held his first exhibition at the Triveni
Gallery, New Delhi, three years after
receiving the National Award of the Lalit
Kala Akademi. He has had several solo
exhibitions in India and Europe and has
also participated in group exhibitions
including *Indian Art Today*, Kunsthalle,
Darmstadt (1982). His works form part of
the collection at the Lalit Kala Akademi,
New Delhi, and private collections. He
lives and works in Delhi.

Tassadaq Sohail (b. 1930)
Born in Julundar, India, he graduated
from the Islamia College, Karachi, and
later studied at St Martin's School of
Art and Central School of Art, London.
He has had solo shows at several galleries
in London: Hawthorndon Gallery
(1976), October Gallery (1979), Horizon
Gallery (1987), Westbourne Gallery
(1990), South Bank Centre (1991), as
well as at the Heritage Gallery, New
Delhi, Indus Gallery, Karachi and
Cachet Arim, Maastricht, Holland
(1993) and the Arabian Gallery, Dubai.
His works form part of the collection of
both the Victoria and Albert Museum,
London, and the Arts Council of Great
Britain. He lives and works in London.

F. N. Souza (b. 1924)
Born in Portuguese Goa, he joined the
Sir J. J. School of Art, Mumbai, in 1940,
but was expelled for organizing a strike
before receiving his diploma. He was
the principal founding member of the
Progressive Artists' Group, which held
its first exhibition in Mumbai in 1948.
He left India and moved to London in
1949 and worked part-time as a journalist
while continuing to paint. He created

a sensation in London in the 1960s,
receiving enormous critical acclaim, and
his works were bought by well-known
personalities and established institutions
such as the Tate Gallery and Oxford
University colleges. He has participated
in many international exhibitions,
including *Art Now in India*, London and
Newcastle-upon-Tyne (1965), *India:
Myth and Reality*, Museum of Modern Art,
Oxford (1982), *Contemporary Indian Art*,
Royal Academy of Arts, London (1982),
Modern Indian Paintings, Hirshhorn
Museum, Washington, D.C. (1982) and
Coups de Coeur, Halles de l'Ile, Geneva
(1987). Since 1970, he has lived and
worked in New York and travels
regularly to India.

K. G. Subramanyan (b. 1924)
Born in Kerala, he received his training
at the Kala Bhavan, Shantiniketan, the
University founded by Rabindranath
Tagore, where he was influenced by
Benode Behari Mukherjee. In the 1940s
he was involved with the struggle for
Independence and in the 1950s he
studied at the Slade School of Fine
Arts, London. He held his first solo
show in Delhi in 1955. In 1966 he was
the recipient of the J. D. Rockefeller III
Fund Fellowship; he has also been
awarded several academic posts –
head of the Faculty of Fine Arts,
M. S. University, Baroda, and has held
a visiting lectureship at the Universities
of MacMaster and Toronto, and more
recently he returned to Shantiniketan as
Head of the Fine Arts Faculty. In 1965 he
received the National Award. His works
are exhibited in the National Gallery of
Modern Art, New Delhi, the Lalit Kala
Akademi, New Delhi, and the Tata
Research Institute, Mumbai. He is an
outstanding art historian and has written
a number of books on the modern
movement in Indian art. He currently
lives and works in Shantiniketan.

Anupum Sud (b. 1944)
Born in Hoshiarpur, she studied at the Delhi College of Art, and then received further training at the Slade School of Fine Arts, London. She held her first solo show in 1967 in New Delhi, which was followed by numerous other solo exhibitions in both India and America. She has also participated widely in group exhibitions including the Third, Fourth and Fifth International Triennales, New Delhi (1974, 1978 and 1982), the *Women's International Exhibition*, New York (1975), and the *Wounds Exhibition*, CIMA Gallery, Calcutta and National Gallery of Modern Art, New Delhi (1993). Her work is part of the permanent collections of the National Gallery of Modern Art, New Delhi, the Victoria and Albert Museum, London, and the Lalit Kala Akademi, New Delhi. Recognized as one of India's foremost female artists, she received the Gold Medal at the *Women's International Art Exhibition*, New Delhi in 1975, the Sahitya Kala Parishad in 1976 and the Printmaking Fellowship Award from the Center for International Contemporary Arts, New York, in 1990.

J. Swaminathan (1928–94)
Born in Simla, Himachal Pradesh, he was an activist in the Communist Party until the mid-1950s and worked as a journalist and art critic in left-wing magazines for about ten years. He briefly studied art at Delhi Polytechnic and the Faculty of Fine Arts, Warsaw, and decided to become a full-time painter in the late 1950s. In 1963 he participated in the foundation of the Group 1890. In 1966 he published the polemical monthly *Contra* in collaboration with the poet Octavio Paz. In 1968 he was awarded the Nehru Fellowship and worked on a project entitled *The Significance of the Traditional Numen in Contemporary Art*. In the course of his long career, he held several

important academic and institutional positions – he was a member of the international jury of the Sao Paulo Biennale, served on the board of the Indian Council for Cultural Relations and was a trustee of the Indira Gandhi National Centre for the Arts. In 1981 he was invited by the Government of Madhya Pradesh to set up the Roopanker Museum at Bharat Bhavan, Bhopal, and was director of the museum until 1990. He had over thirty solo shows in his life time and participated in many national and international exhibitions.

Gaganendranath Tagore (1867–1938)
Born in Calcutta, in 1907 he founded the Indian Society of Oriental Art along with his brother Abanindranath Tagore. He was a self-taught artist influenced by Japanese art and other Far Eastern styles and later in his career developed his own brand of cubism. However, he is best known for his political cartoons and social satires on westernized Bengalis. His work was exhibited in Paris (1914), London, Belgium and Holland, and in a travelling exhibition organized by the American Federation of Art and ISOA in London and Germany (1924).

Rabindranath Tagore (1861–1941)
Born into an aristocratic landowning Bengali family, Rabindranath was the fourteenth child. He was awarded the Nobel Prize for Literature in 1913 and only started painting at the age of sixty-nine. His first exhibition was held at the Galerie Pigalle, Paris (1930). The Barbican Art Gallery in London held an important exhibition of his works in 1986. He founded the Visva Bharati University at Shantiniketan in 1917.

V. Tewari (b. 1955)
Born in Calcutta, she studied literature and law, and later art at Triveni Kala Sangham, New Delhi (1981). She has

participated in several group exhibitions including the first International Biennale of Plastic Arts, Algiers (1987), the Sixth International Triennale, New Delhi (1986), and First Bharat Bhavan Biennale, Bhopal. A recipient of the National Cultural Scholarship and the Silver Medal at the First International Biennale of Plastic Arts, her works are exhibited in the National Gallery of Modern Art, New Delhi, Masanori Fukuoka collection, Japan, and Chester and David Herwitz collection, America. She presently lives and works in New Delhi.

Ramkinkar Vaij (1910–80)
Born in Bankura, West Bengal, he received his diploma from Kala Bhavan, Shantiniketan, and went on to become Head of the Sculpture Department there. Despite being a talented painter, he is best known for his expressionistic sculpture which, like his paintings, are spontaneous and bold. His works have been included in several exhibitions such as the *Asian Art Exhibition*, Tokyo (1979) and *Man and Nature: Reflections of Six Artists*, Indian National Trust for Art and Culture Heritage and National Gallery of Modern Art, New Delhi (1995). A retrospective of his work was held at the National Gallery of Modern Art, New Delhi (1990) and his work was included in the Shantiniketan exhibition at the National Gallery of Modern Art, New Delhi, in 1997.

S. G. Vasudev (b. 1941)
Born in Mysore, he studied at the Government College of Arts and Crafts, Chennai. He has regularly participated in the National Exhibition of Art and in exhibitions organized by the Academy of Fine Arts, Calcutta, the Hyderabad Art Society and the Bombay Art Society. He has held several solo shows in Bangalore, Hyderabad,

Chennai, Mumbai and New Delhi and in Canada, America and Germany. He has participated in various group exhibitions, among them *Contemporary Indian Art*, Norway, Denmark, Belgium (1967), Paris Biennale (1968), Second Biennale, Cuba (1986) and the *International Exhibition of Drawing*, Yugoslavia (from 1972). A recipient of the Lalit Kala Akademi National Award in 1967, his works are exhibited in the National Gallery of Modern Art, New Delhi, Lalit Kala Akademi, New Delhi, and the Salar Jung Museum, Hyderabad.

V. Viswanadhan (b. 1940)
Born in Kerala, he studied at the Government School of Arts and Crafts in Chennai. He has had many solo exhibitions and has participated in a series of group exhibitions at, for instance, the Gallery Chemoud, Mumbai, and in Paris, Stockholm and New York. His work forms part of the collections of the National Gallery of Modern Art in New Delhi, the Musée d'Art Moderne and Palais de Tokyo, Paris. He received a National Award for Painting from the Lalit Kala Akademi in 1968. In 1997 he exhibited at the Vadehara Art Gallery in New Delhi. He has made a number of films and now lives mainly in Paris, but also in India.

Bibliography

General books and monographs
Anand, Mulk Raj, *The Hindu View of Art*, intro. by E. Gill, Asia Publishing House, London, 1957

Bartholomew, R., and Kapur, S., *Husain*, Harry N. Abrams, Inc., New York, 1971

Bickelmann, U., and Ezekiel, N., *Artists Today*, Marg Publications, Mumbai, 1987

Contemporary Indian Sculpture – The Madras Metaphor, Oxford University Press, Oxford, 1993, pp. 12–35

Coomaraswamy, Ananda K., *Christian and Oriental Philosophy of Art*, Dover Publications, New York, 1st ed. 1943, 2nd ed. 1956

Doshi, Dr Saryu, *Pageant of Indian Art*, Marg Publications, Mumbai, 1983

Goswamy, B. N., *Essence of Indian Art*, Asian Art Museum of San Francisco, 1986

Gray, Basil, *The Arts of India*, Phaidon, Oxford, 1981, pp. 215–16

Greenberg, Clement, 'Avant-Garde and Kitsch' (1939), reprinted in *Art and Culture: Critical Essays*, Beacon Press, Boston, 1989, pp. 3–4

Hore, Somnath, *Tebhaga*, Seagull Books, Calcutta, 1990

Hughes, Robert, *Nothing If Not Critical*, Harvill Press, London, 1987 and 1995

Images of the Raj, private publication, Bangalore, 1986

Kapur, Geeta, *Husain*, Vakils, Mumbai, 1968

———, *Contemporary Indian Artists*, Vakils, Mumbai, 1978

Kaviraj, Sudipta, 'The Imaginary Institution of India', in *Subaltern Studies VII: Writing on South Asian History and Society*, Oxford University Press, New Delhi, 1992, p. 33

Mitter, Partha, *Much Maligned Monsters*, University of Chicago Press, Chicago, 1977 and 1992

———, *Art and Nationalism in Colonial India 1850–1922*, Cambridge University Press, Cambridge, 1994

Mookerjee, Ajit, *Modern Art in India*, Oxford and Calcutta, 1956

Parimoo, Ratan, *The Painting of the Three Tagores: Abanindranath, Gaganendranath, Rabindranath, Chronology and Comparative Study*, Maharaja Sayajirao University of Baroda, 1973, pp. 38–40 and 72–87

Passage into Human Space, intro. by Chester Herwitz, Folio, Armsos, New York, 1979

Peerboy, Ayaz, *Paintings of Husain*, Thackery, Mumbai, 1955

Poetry to be Seen, private publication, Geneva, 1973

Rushdie, Salman, 'Imaginary Homelands', in *Imaginary Homelands: Essays and Criticism 1981–1991*, Granta Books/Viking Penguin, New York, 1991, p. 20

Singh, Wark, *Triangles*, private publication, Geneva, 1975

Sokolowski, T., Patel, G., and Herwitz, D., *Contemporary Indian Art*, based on the Exhibition Catalogue of the Festival of India Exhibition, Grey Art Gallery and Study Centre, New York University, New York University Press, 1985

Subramanyam, K. G., *The Living Tradition: Perspectives on Modern Indian Art*, Seagull Books, Calcutta, 1987, p. 35

——, *The Creative Circuit*, Seagull Books, Calcutta, 1992

Taylor, Brandon, *The Art of Today*, Weidenfeld and Nicholson/Everyman Art Library, London, 1995, p. 169

Thakurta, Tapati Guha, *The Making of a New 'Indian' Art: Artists, Aesthetics and Nationalism in Bengal, c. 1850–1920*, Cambridge University Press, Cambridge, 1992, p. 202

——, 'Raja Ravi Varma and the Project of New National Art', in *Raja Ravi Varma New Perspectives*, R. C. Sharma (ed.), National Museum, New Delhi, 1993

Tribute to Picasso, Nine Decades of Performance, private publication, New York, 1980

Ypma, Herbert, *India Modern – Traditional Forms and Contemporary Designs*, Phaidon Press, London, 1994

Exhibition catalogues
Akbar Padamsee, Mirror Images, Pundole Art Gallery, Mumbai, 1994

Amrita Sher-Gil, Marg Publications, Mumbai, 1973

Art Now in India, Arts Council of Great Britain, London, 1965

Commonwealth Artists of Fame, text by Donald Bowen, Commonwealth Institute, London, 1977

Contemporary Indian Art, text by Geeta Kapur, Festival of India, The Royal Academy of Arts, published by the India Advisory Committee, London, 1982

Culture of the Streets, intro. by Chester Herwitz, Art Heritage Gallery, New Delhi, 1981

Festival of India, intro. by Pupul Jayakar, Harry N. Abrams Inc., New York, 1985

India: Myth and Reality, Aspects of Modern Indian Art, text by D. Elliot, V. Musgrave and E. Alkazi, Museum of Modern Art, Oxford, 1982

Indian Art Today, text by D. Herwitz and Partha Mitter, Phillips Collection, Washington, D. C., 1986

Jehangir Sabavala, Lalit Kala Akademi, New Delhi, 1984

Krishna Reddy, A Retrospective 1981–82, Bronx Museum of the Arts, New York, 1981

Laxman Shrestha, text by Kamla Kapoor, Jehangir Art Gallery, Mumbai, 1993–94

Les Otages-Mère Thérésa, Place d'Artes, Galerie Jourdan, Montreal, 1981

Pictorial Space, text by Geeta Kapur, Lalit Kala Akademi, New Delhi, 1977

Place for People, Jehangir Art Gallery, Mumbai, 1981

Portrait of an Umbrella, text by E. Alkazi, Art Heritage Gallery, New Delhi, 1978

Rabindranath Tagore, A Celebration of his Life and Work, Museum of Modern Art, Oxford, 1986

Retrospective Exhibition of M. F. Husain, Birla Academy of Art and Culture, Calcutta, 1973

Selected Expressionist Paintings from the Collection of the National Gallery of Modern Art, text by Laxmi Sihari, National Gallery of Modern Art, New Delhi, 1975

Seventeen Indian Painters, Gallery Chemould, Mumbai, 1988

Shasthi Poorji (1915–1975), foreword by Dr M. R. Anand, Commonwealth Institute Art Gallery, London, and Tata Press, Mumbai, 1974

Six Indian Painters, Tate Gallery, London, 1982

Souza in the 'Forties', text by Jag Mohan, Dhoomi Mal Gallery, New Delhi, 1983

Story of a Brush, Gallery Pundole, Mumbai, 1983

Tyeb Mehta, Vadehara Art Gallery, New Delhi, 1996

Wounds, CIMA Gallery, Calcutta, 1993

Articles in journals and periodicals
Ananth, Deepak, 'Storm Over Asia – The Art of Vivan Sundaram', *Art and Asia Pacific Quarterly Journal*, Vol. 2, No. 1, January 1995

Bobb, Dilip, and Jerath, Arati, 'A Touch of Class: Artist M. F. Husain', *India Today*, Vol. IV, No. 3, February 1979

Dalmia, Yashodhara, 'That Brief Thing Called Modern', *Art and Asia Pacific Quarterly Journal*, Vol. 2, No. 1, January 1995

Gablik, Suzi, 'Report From India', *Art in America*, New York, No. 5, September 1979

Gupta, Kalyan Kumar Das, 'Abanindranath Tagore – The Spirit Behind the Bengal School', *Lalit Kala Akademi Contemporary*, 38, March 1993, pp. 52–63

Hanru, Hou, 'An Interview with Rasheed Araeen', *Art and Asia Pacific Quarterly Journal*, Vol. 2, No. 1, January 1995

Hinterthur, Petra, 'Maqbool Fida Husain', *Orientations*, Hong Kong, April 1983

Hoskote, Ranjit, 'Rabindranath Tagore: Portrait of a Prophet as an Anarchist', *Humanscape*, Mumbai, Vol. II, Issue VIII, 1995, p. 25

Jain, Jyotindra, 'Art and Artisans – Adivasi and Folk Art in India', *Art and Asia Pacific Quarterly Journal*, Vol. 2, No. 1, January 1995

Kapur, Geeta, 'One Hundred Years', *Art and Asia Pacific Quarterly Journal*, Vol. 2, No. 1, January 1995

Krishnan, S. A., 'M. F. Husain', *Lalit Kala Akademi Contemporary*, 27, April 1979

Matilal, Bimal Krishna, 'Logic, Language and Reality', *Motilal Benarsi Das*, Delhi, 1990, pp. 164–202

Nandy, Pritish, 'The Master: The Life and Times of M. F. Husain', *The Illustrated Weekly*, Mumbai, 4–10 December, 1983

Narayanan, Badri, 'Murals in Bombay', *Lalit Kala Akademi Contemporary*, 14, April 1972

Patel, Baku, 'Husain's Hanumans', *The Illustrated Weekly*, Mumbai, 31 January–6 February 1982

Rawson, Philip, 'Contemporary Indian Art Exhibition at Newcastle', *Lalit Kala Akademi Contemporary*, 5, September 1966

Saari, Anil, 'Why Artists Have Politics', *Fortnight Magazine*, New Delhi, Vol. 11, No. 17, 10 September 1979

Sarkar, Sandip, and Mazumdar, Nirode, 'A Solitude for Painting', *Lalit Kala Akademi Contemporary*, 22, pp. 7–9

Singer, Ansoli, 'Compassion for Struggling Humanity', *Our Artists Series*, Chennai, 1979

Singh, C., 'Notes on Some Early Works of M. F. Husain', *Lalit Kala Akademi Contemporary*, 15, February 1973

Subramanyam, K. G., 'The Drawings of Nandalal Bose', *Art Heritage*, 2, New Delhi

Vajpei, Ashok, 'A Furious Purity – Tribute to J. Swaminathan', *Art and Asia Pacific Quarterly Journal*, Vol. 2, No. 1, January 1995

Acknowledgments

We would like to thank Peter De Francia, Joanna Drew and Ranbir Kaleka (London), and Alnoor Mitha (Manchester) for graciously loaning research material from their archives. We are also grateful to the following people for supplying photographic material: Sharon Apparao (the Chennai area), Supriya Banerjee (Gallery 88, Calcutta), Patrick Bowring and Simon Taylor (Sotheby's, London), Mr Masanori Fukuoka (Glenbarra Art Museum, Japan), Professor Josef James (Chennai), Amrita Jhaveri and Sasha Altaf (Mumbai, Ahmadabad and the neighbouring areas), Aziza and Zia Kurtha, Emma Pearl at the Lisson Gallery (London), Meera Menezes (the Delhi area), Mr Jehangir Nicolson (Mumbai), Prakash Rao (Mumbai) for making a number of slides, Rakhi Sarkar (CIMA, Calcutta), Anjolie Sen (National Gallery of Modern Art, New Delhi) and Mr Anwar Siddiqi (London). We would also like to thank Yashodara Dalmia for her general advice, Professor K. G. Subramanyan for his immensely valuable comments, Naveen Kishore of Seagull Books for having put us in touch with Professor Subramanyan, Yvonne McFarlane and Peter Townsend for their superb editorial help, Mr Ranjit Hoskote for his general encouragement, Pat Fakhri and Tina Ahmed from Dubai, and Rupika Chawla for her assistance and encouragement. Thanks also to all the artists for their help and for allowing their pictures to be used. A special thanks goes to Sakti Burman, Bal Chhabda and M. F. Husain for their advice and encouragement at all times, and also to Tyeb Mehta, Mrinalini Mukherjee, Akbar Padamsee, Gieve Patel, A. Ramachandran, S. H. Raza and Jahangir Sabavala.

The following abbreviations have been used: a above; b below; l left; r right.
Collection the Arts Council of England 89b; Christie's, London 112l, 112r; CIMA, Calcutta 77l, 85l, 97, 104a, 120, 122, 125a; Glenbarra Art Museum, Japan 79b, 87al, 90b, 91al, 95, 96, 103b, 104b, 106a, 110, 115a, 119r, 128r; C. Herwitz 76l; © Imperial War Museum 101r; Courtesy Lisson Gallery, London 123 (Photo Andrew Penketh), 128l (Photo Edward Linden); M. Mukherjee collection 57a, 57b; National Gallery of Modern Art, New Delhi 49, 58, 59l, 59r; Jehangir Nicholson Museum, Mumbai 60, 66r, 67, 69a, 69b, 78al, 78ar, 78b, 80r, 82, 84l, 86a, 87b, 87ar, 99l; Ms Panniker 90a; Sotheby's, London 50, 51, 52, 54, 56l, 56r, 61b, 62, 64a, 73, 76r, 79ar, 80l, 85r, 86b, 88a, 88b, 91b, 102a, 109r. All other photographs courtesy the artist.

Index

Page numbers in italic refer to illustrations and those in bold to entries in the Biographies.

Abstract Expressionism 35
Achutan, K. *115*
Alkazi, E. 29
Altaf, Navjot *116, 119*
Anand, Mulk Raj 22, 24
Ara, K. H. 20, **130**
Archer, W. G. 26, 27
Art Nouveau 33
Aurangzeb, Emperor 10

Bakre, S. K. 20, *62*
Banerjee, Amitabha **130**
Baroda Art School, the 30, 41
Baroda State Museum, the 22
Baroda University 38
Barwe, Prabhakar *119*
Bauhaus, the 14, 15, 16, 37
Bawa, Manjit 43, *104*, **130**
Bendre, N. S. 24, **130**
Bengal School, the 9, 12, 13, 17, 21
Bhabha, Homi 30
Bhargava, Veena **130**
Bhatt, Jyoti *120*
Bhattacharjee, Bikash *121*, **130**
Bhulabhai Institute, Mumbai 25, 29
Bose, Nandalal 9, 15
Brancusi, Constantin 37
Broota, Rameshwar *91*, **131**
Burman, Sakti *105*, **131**

Calcutta School of Art 9, 15
Caur, Arpana 17, 43, *110, 111*, **131**
Celant, Germano 45
Central School of Art, London 26
Chakravorty, Jayashree **131**
Chandra, Avinash 26–27, *73, 74*, **131**
Chaudhry, Sankho 10–11, 16, 24, 25, 30, 35
Chhabda, Bal 24, 35, *82, 83*, **131**
Chola period 10
Chowdhury, Jogen 42–43, *102, 103*, **131**
Connor, David *128*
Coomaraswamy, Ananda 9, 13
Cubists 22

Dalí, Salvador 36
Das, Sunil **132**
Das Gupta, Dharmanarayan **132**
De, Biren 25, 37, *91*, **132**
De Francia, Peter 25
Dodiya, Atul 44, *108*
Douglas, C. **132**
Duerden, Dennis 27
Dyer, General 15

East India Company, the 10
Ecole des Beaux-Arts, Paris 17, 18

Fauvists 22
Feininger, Lyonel 16

Gade, H. A. 20, *66*, **132**
Gaitonde, V. S. 24, 25, 36, *69, 87*, **132**
Gandhi, Indira 40–41
Gandhi, Kekoo 25
Gandhi, Mahatma 9, 22
Ganguly, Jaya **132**
Gauguin, Paul 18, 21
Genghis Khan 7
Ghilardy, O. 13
Goud, Laxma *106*, **132**
Gujral, Satish 19, 24, 31, 36, 39, *67, 77*, **133**
Guptas, the 6, 10

Haloi, Ganesh **133**
Havell, E. B. 9, 12, 13, 14, 15
Hebbar, K. K. *64, 86*, **133**
Hockney, David 39, 44
Hopper, Edward 44
Hore, Somnath 10, *71*, **133**
Husain, M. F. 20, 22, 23, 25, 27–28, 34, *60, 61, 75, 76*, **133**
Husain, Shamshad **133**

Impressionists 22
Indian Arts Council, UK 46
Indian Council for Cultural Relations 24, 26
Indian folk art 22
Indus Valley Civilization 6, 22

Jaipur, Maharajah of 24
Jehangir Art Gallery, Delhi 25

Kaleka, Ranbir 25, 41–42, *98, 99*
Kalighat paintings 12–13, 14, 21, 39
Kandinsky, Vassily 16
Kapil Jariwala Gallery, London 46–47
Kapoor, Anish 11, 45, *123, 128*, **133**
Karmakar, Prokash **134**
Khajuraho 10, 22, 26
Khakhar, Bhupen 30, 38, 39–40, *96, 97*, **134**
Khanna, Balraj 26, 36, *89*, **134**
Khanna, Krishen 24, 25, 35, *84, 85*, **134**
Klee, Paul 16, 26, 36, 37
Kolte, Prabhakar *122*
Kumar, Ram 24, 25, 32, *68, 78*, **134**
Kumar, Ravi 36
Kushans, the 6, 10

Léger, Fernand 12
Lewis, Wyndham 16

Mahmud of Ghazni 10
Maity, Paresh 44–45
Malwa miniatures 39
Manet, Edouard 20
Marcks, Gerhard 16

Márquez, Gabriel García 40
Matisse, Henri 39
Mauryas, the 6, 10
Mazumdar, Chitravanu **134**
Mehta, Tyeb 24, 25, 30–31, *84, 85*, **135**
Menon, Anjolie Ela 17, 43, 44, *109, 112*, **135**
Miró, Joan 36
Mistry, Dhruva 11, 25, 38, 45, *125, 126, 127*, **135**
Mohamedi, Nasreen 17, 35, 44, *113*
Mondrian, Piet 37
Mookerjee, Ajit 22, 36–37
Mughal painting 31, 41
Mughal-Rajput miniature paintings 7, 9
Mughals, the 6, 7, 10
Mukherjee, Benode Behari 15, 17, 39, *57*
Mukherjee, Meera 17, 43, *107*, **135**
Mukherjee, Mrinalini 17, 38, 43, 44, *126*, **135**
Mukherjee, Sailoz 25, *66*
Mullins, Edwin 27

Nair, Surrendran 44, *124*
Narayan, Badri *106*
Nasser, Gamal Abdel 29
Nayar, Ved 128
Nehru, Jawaharlal 20, 29, 38

Op art 24, 37

Padamsee, Akbar 23 25, 34, 42, *80, 81*, **135**
PAG (Progressive Artists' Group) 19, 20, 21–22, 23, 24, 27, 29, 34, 36
Pai, Laxman 24, *70*, **136**
Pal, Gogi Saroj 17, 44, *114*
Palmer, Charles 13
Panchal, Shanti *101*, **136**
Paniker, K. C. S. 37, *90*
Parekh, Manu **136**
Patel, Gieve 42, *100*, **136**
Patel, Jeram 35, 36
Patel, Trupti 17, 25, 38, 44, *116, 117*, **136**
pats see Kalighat paintings
Patwardhan, Sudhir 42, *99*, **136**
Picasso, Pablo 45
Pop art 24, 39, 40
Progressive Artists' Group *see* PAG
Pyne, Ganesh 33, *79*, **136**

Raja Ravi Varma 11, 17, *50, 51*, **137**
Rajput painting 19, 33
Ramachandran, A. 25, 32–33, **137**
Rawson, Philip 27, 37
Raza, S. H. 20, 22, 25, 34, 37, *91*, **137**
Realism 38–45
Reddy, Krishna 25, **137**
Revivalists *see* the Bengal School

Rimzon, N. N. 45, *125*, **137**
Rodwittiya, Rekha 17, 25, 38, *117, 118*, **138**
Rothko, Mark 37
Roy, Indrapramit **138**
Roy, Jamini 13, 14, 21, *54, 55, 56*, **138**

Sabavala, Jahangir 24, *81*, **138**
Salon des Refusés 20, 21
Samant, Mohan 35, *87*
Santosh, G. R. 25, 37, *90*, **138**
Sarkar, Rakhi 46
Sehgal, Amarnath 10
Shah, Himmat 36
Shankar, Ravi 29
Shantiniketan 9, 10, 14, 15–16, 17, 21, 33, 35, 38
Shaw, Lalu Prasad **138**
Sheikh, Gulam Mohammed 25, 36, 38, 41, **138**
Sher-Gil, Amrita 15, 17–19, 21, 32, 44, *58, 59*, **139**
Silpi Chakra Group 29, 39
Simon, Lucien 17
Singh, Arpita 17, 43, *109, 111*, **139**
Singh, Paramjit 43, **139**
Siqueiros, David Alfaro 31
Sohail, Tassadaq 19, 32, *77*, **139**
Souza, F. N. 20, 23, 25, 26, 27, 28, 30, 34, *63, 64, 65, 72*, **139**
Spender, Stephen 26
Srinivasan, P. 44
Subramanyan, K. G. 14, 16, 25, 30, 38, 39, *93, 94, 95*, **139**
Sud, Anupum **140**
Sundaram, Vivan 17, 19, 25, 36, 38, 41
Swaminathan, J. 35, 36, *88*, **140**

Tagore, Abanindranath 9, 12, 13, 14, 15, 19, 21, 33, *53*
Tagore, Gaganendranath 9, 12, *52*, **140**
Tagore, Rabindranath 9, 10, 14, 15–17, 21, 39, *49, 59*, **140**
Tàpies, Antonio 35
Tewari, V. *121*, **140**
Travancore, house of 11

Vaij, Ramkinkar 10, 15, 35, 39, *56*, **140**
Vasarély, Victor de 37
Vasudev, S. G. **140**
Viswanadhan, V. *92*, **141**
Von Leyden, Rudy 22